WITHDRAWN

THE ART OF MONOPRINT

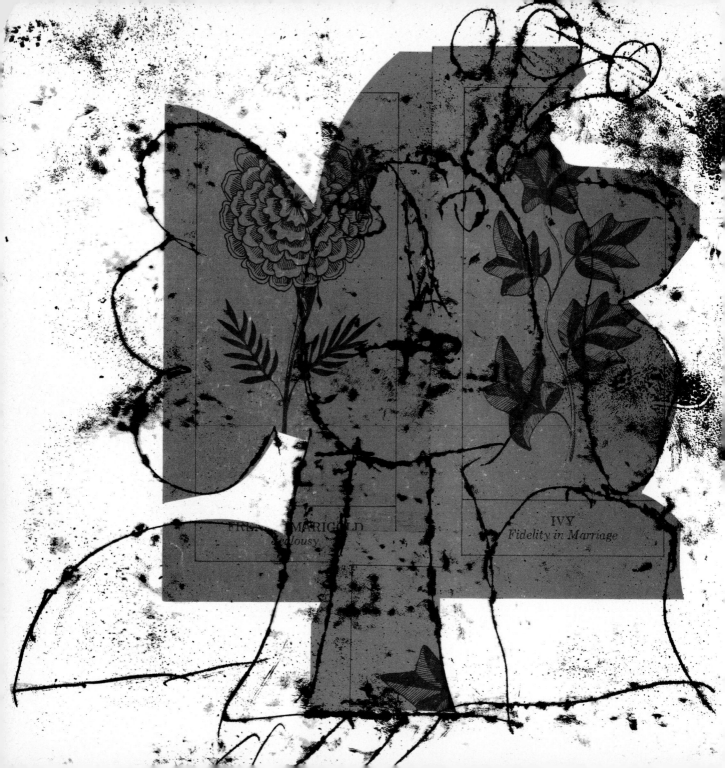

THE ART OF MONOPRINT

History and Modern Techniques

Norman Laliberté/Alex Mogelon

An Art Horizons Book

Van Nostrand Reinhold Company
New York Cincinnati London Toronto Melbourne

To Nicholas

Library of Congress Catalog Card No. 73–1635
ISBN 0–442–24607–2

Design consultant: Milton Glaser

Published in 1974 by Van Nostrand Reinhold Company
A Division of Litton Educational Publishing, Inc.
450 West 33rd Street, New York, N.Y. 10001

16 15 14 13 12 11 10 9 8 7 6 5 4 3 2 1

Also by the authors:
Masks, Face Coverings and Headgear (1973)
Pastel, Charcoal and Chalk Drawing (1973)
The Art of Stencil (1971)
Twentieth-Century Woodcuts (1971)
Collage, Montage, Assemblage (1971)
Drawing with Ink (1970)
Drawing with Pencils (1969)
Silhouettes, Shadows and Cutouts (1968)
Painting with Crayons (1967)
Banners and Hangings by Norman Laliberté
and Sterling McIlhany (1966)
Wooden Images by Norman Laliberté
and Maureen Jones (1966)

The authors and Van Nostrand Reinhold Company have
taken all possible care to trace the ownership of every work
of art reproduced in this book and to make full acknowledg-
ment for its use. If any errors have accidentally occurred,
they will be corrected in subsequent editions, provided
notification is sent to the publisher.

Library of Congress Cataloging in Publication Data
Laliberté, Norman
The Art of monoprint.

(An Art horizons book)
1. Monotype (Engraving) I. Mogelon, Alex, joint
author. II. Title.
NE2242.L34 760'.28 73–1635
ISBN 0–442–24607–2

Frontispiece:
Marigold and Ivy by Norman
Laliberté. A monoprint on
clear acetate. Printed colored
paper was cut to follow the
shape of the monoprint; draw-
ing was adhered to the mono-
print while the ink was wet.

Opposite Page
The imprint of a hand from an
inked plate.

Contents

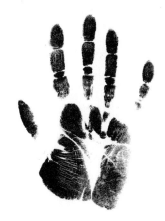

1.
Early History

It is commonly believed that the monotype or monoprint was developed in the 17th century by the Italian painter and printmaker Giovanni Benedetto Castiglione (1616–1670). By its very nature, the monoprint was not destined to become a popular medium because each printing was limited to an edition of one.

A general description of a monotype is a work of art printed from a still-wet ink drawing made on a hard, perfectly flat surface such as a sheet of glass, metal or wood. The ink used is usually printer's ink or thinned oil paint, and the composition is printed by being run through a press or rubbed by hand. Though there are a number of variations in practice by contemporary artists (including drawing on the back of a paper which has been placed over an inked plate), the basic principle in producing monoprints remains the same. There are no raised lines or acid areas burned into the plate, and, therefore, the original drawing made in ink transfers itself and is consumed entirely in the finished work.

Castiglione, who was greatly influenced by the prints and etchings of Van Dyck, produced some twenty monotypes in his lifetime, for the most part Biblical and illustrative in subject matter. The medium failed to become popular, not only because of its severe limitation of one print for each drawing created, but also because it seemed to depend too heavily on accidental effects and the uncontrollable properties of ink or paint on a flat surface when subjected to the pressure of a press or to hand rubbing. Rembrandt (1606–1669) was known to have executed a number of monotype-like etchings and drawings, but for a long time, except for the work of Castiglione, the medium remained without an active following.

About a century later, the monoprint or monotype was rediscovered through experimentation in monochrome color transferring by William Blake (1757–1827), the artist and poet who used the medium to illustrate a number of his writings. It is said that Blake kept his method of producing monotypes a closely guarded secret and that some of the monotypes were used as a guide for overpainting or coloring in another medium.

Camille Pissarro (1831–1903) made a number of monoprints, most of them quite classical in content, but it was not until the era of Edgar Degas (1834–1917) that the monotype or monoprint was to receive greater acceptance and recognition. For here was the first artist capable of taking advantage of the immense spontaneity of the medium and, at the same time, able to unlock something of its full potential.

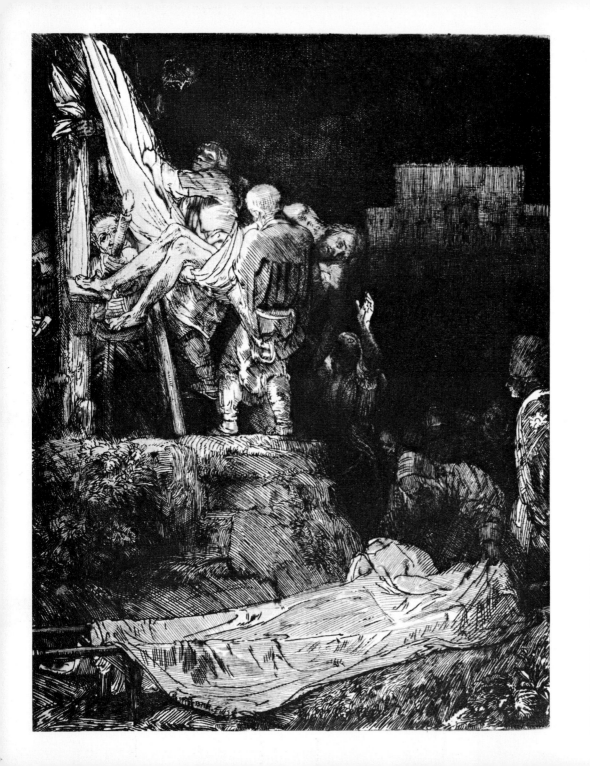

Descent From The Cross,
an etching-monotype by
Rembrandt van Rijn
(1606–1669). This is still
another example of
Rembrandt's technical
versatility. The composi-
tion has the controlled
linear quality of an etching.
Four details from the
same work are isolated
and reproduced on the
opposite page. Note the
multiplicity of line
qualities all within the
same monoprint.
(Courtesy, British
Museum.)

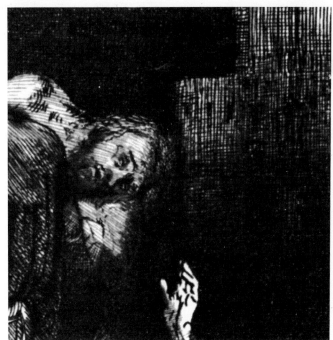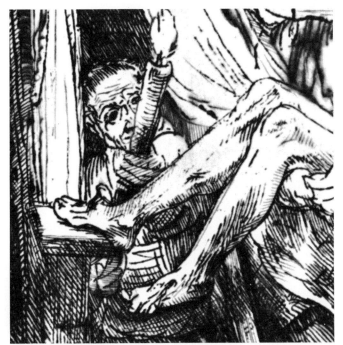

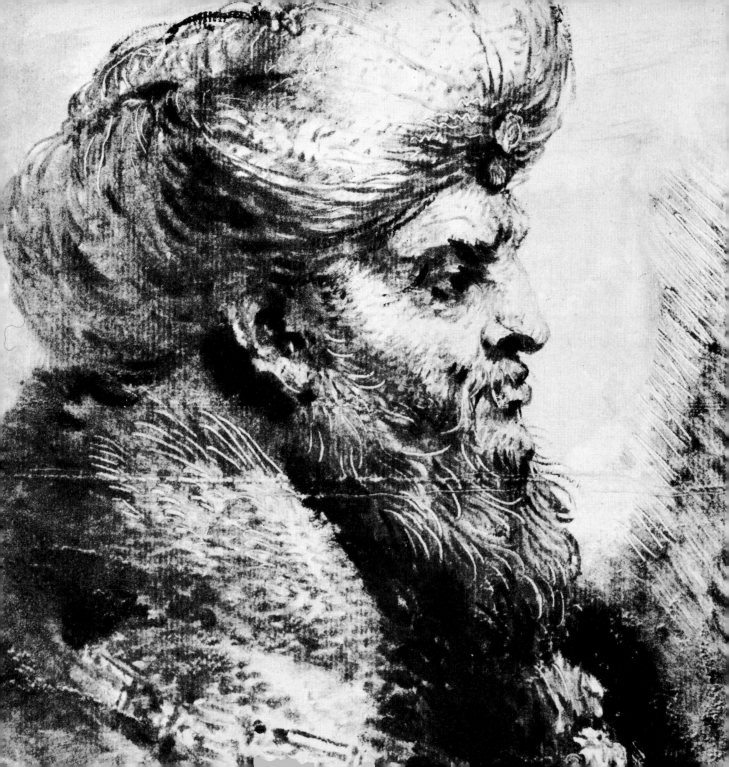

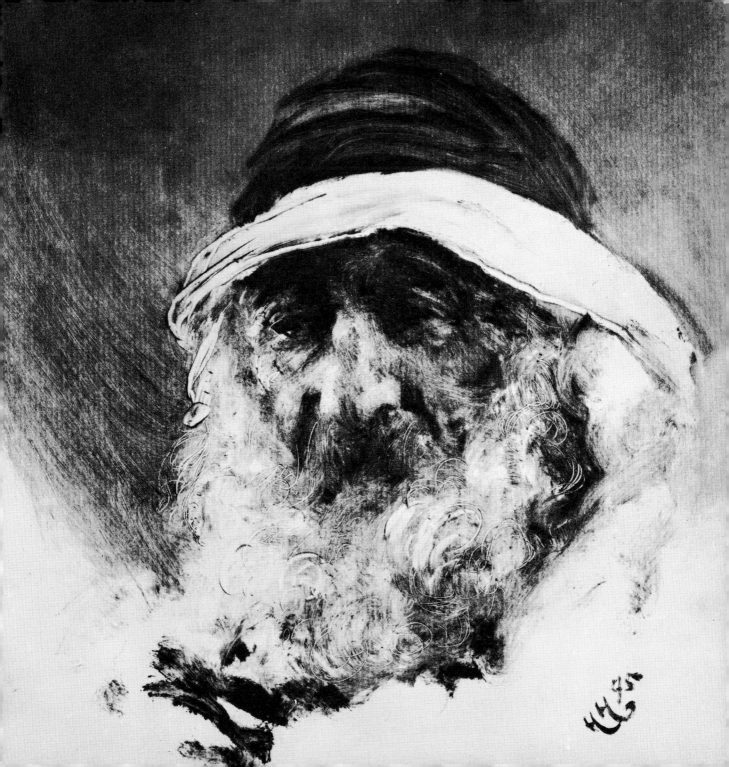

Head of an Oriental by Giovanni B. Castiglione (1616–1670). A soft pastel quality has been achieved through very light pressure applied on the back of the paper. It appears as if some rubbing and scratching were added to the monoprint after it had been pulled from the plate. (Courtesy, Royal Library, Windsor Castle. Copyright reserved.)

Head of an Old Man by Sir Hubert von Herkomer (1849–1914). The paper on which the artist worked contributes a textured quality to the monoprint. Note how the hat has been created with just a few strokes on the back of the print. An area of ink has been pulled off the plate to achieve the white effect of the headband, while a variety of scratchings in the monoprint itself serves to give the beard both definition and detail. (Courtesy, Library of Congress, Washington, D.C.)

Above: The Nativity. Below: untitled, both by Giovanni B. Castiglione (1616–1670). These two monoprints provide a good study of Castiglione's monoprint techniques. In *The Nativity* a highly dramatic effect is achieved through the very strong, almost regimented manner in which the composition has been rendered. The untitled monoprint is soft and somewhat loose; its overall appearance is that of a watercolor. (Courtesy, Royal Library, Windsor Castle. Copyright reserved. Photos by A. C. Cooper Ltd.)

Opposite Page

Detail from *Christ Appearing to the Apostles*, a monoprint with ink lines added, by William Blake (1757–1827). Blake was a master draftsman, and the monoprint was another dimension of his versatility. (Courtesy, Rosenwald Collection, National Gallery of Art, Washington, D.C.)

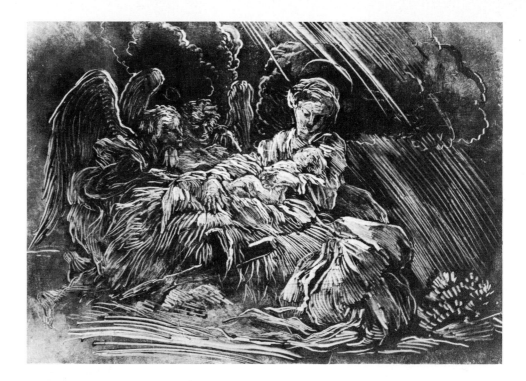

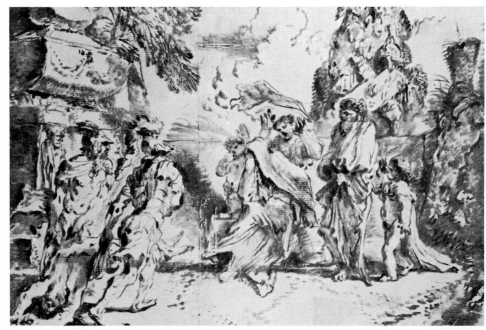

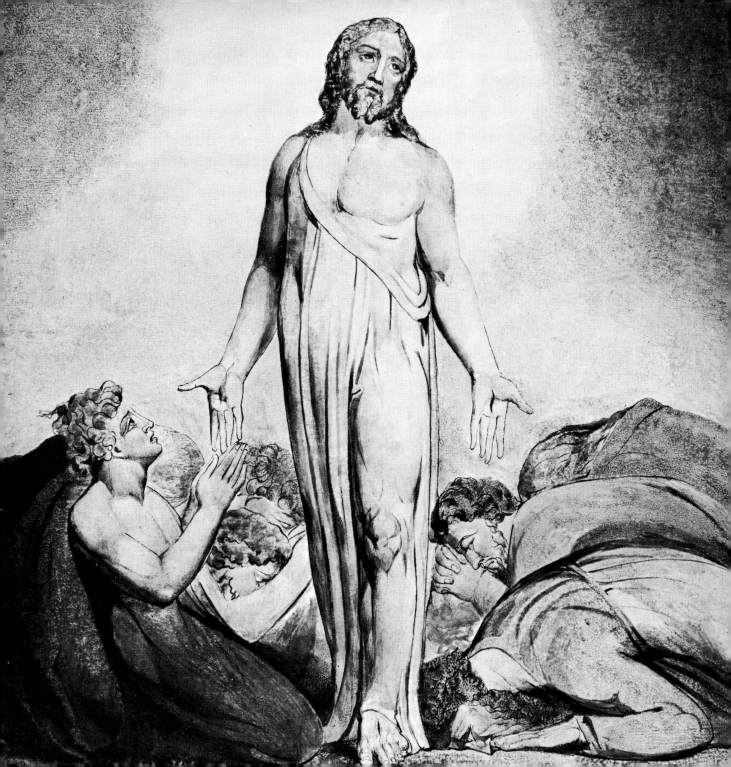

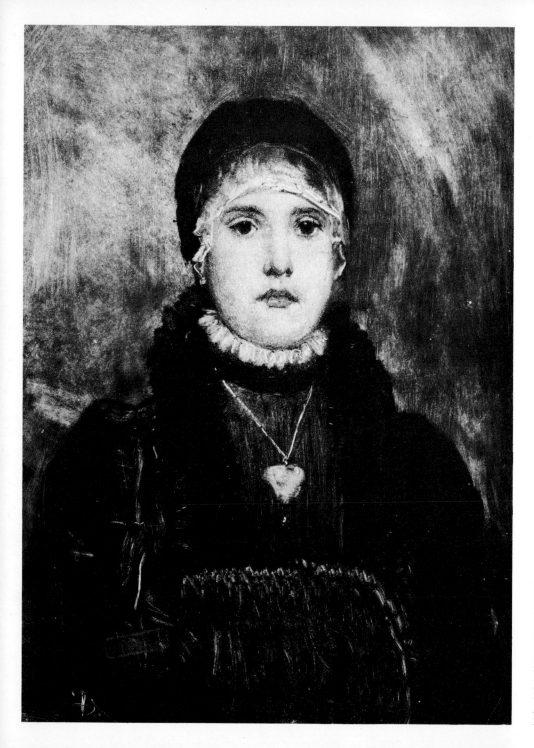

Portrait of a Girl by Frank Duveneck (1848–1919). This is a fine example of the monoprint technique conveying the impression of a portrait executed in the oil medium. The artist shows tremendous control with respect to the light areas in his monoprint. Note the softness of the face and the lacy quality of the hat and collar. At the same time, compare the soft, textured background with the hard, solid black of the coat and muff. (Courtesy, Cincinnati Art Museum. Gift of Frank Duveneck.)

2.
Early American Monoprints

This section includes a number of earlier monoprints by American artists. Perhaps the first of these was Charles A. Walker, who lived in Boston and is believed to have discovered the medium independently while experimenting in print techniques toward the end of the 19th century. However, by far the best known early American exponent of the medium was Maurice Brazil Prendergast (1859–1924), who earned his reputation as a painter in the watercolor medium. Prendergast visited Europe a number of times and was influenced greatly by the work of Cezanne. He executed some 200 monoprints in his lifetime, many of them in soft and subtle colorations.

Other early monoprints shown in this book are by Frank Duveneck, Gifford Beal, Ruel P. Tolman, William Merritt Chase, Abraham Walkowitz, John Sloan, Charles Dahlgreen, William Zorach, George O. "Pop" Hart and Glenn O. Coleman.

For some reason, there has been controversy about accepting the monoprint as a full-fledged medium, and some have claimed that it is treated as a step-child or even as an illegitimate child in the printmaking family. A number of American competitions and exhibitions in the printmaking field have barred monoprints for no explainable reason. Print dealers have been known to refuse to carry them, but this in a way is understandable, for unlike lithographs, for instance, a monoprint is equivalent to an original in every sense of the word.

It may be that unlike other media, the monoprint has no continuing history or tradition, and that each artist seems to discover and rediscover the medium over and over again in his or her way, almost as an accidental happening, while exploring one form of printmaking or another. Without a heritage or a constant following, the monoprint has had a rough time in finding the acceptance to which it is entitled.

Whatever the reason for this prejudice, it has not succeeded in discouraging the use of the medium simply because there is an adventuresome and perhaps unparalleled spontaneity in its execution. The medium has a great spirit of both curiosity and mystery about it because the transfer process from one surface to another has an overwhelming sense of unpredictability. There is a personal challenge in producing an acceptable monoprint (acceptable to the artist, that is) which is difficult to define. Each application and manipulation of ink is rife with possibilities, and always, while anxiously peering at the underside of a composition being pulled from the plate, the artist experiences a moment of truth. For in the transition from inked plate to paper, he experiences the creative anticipation that makes him what he is.

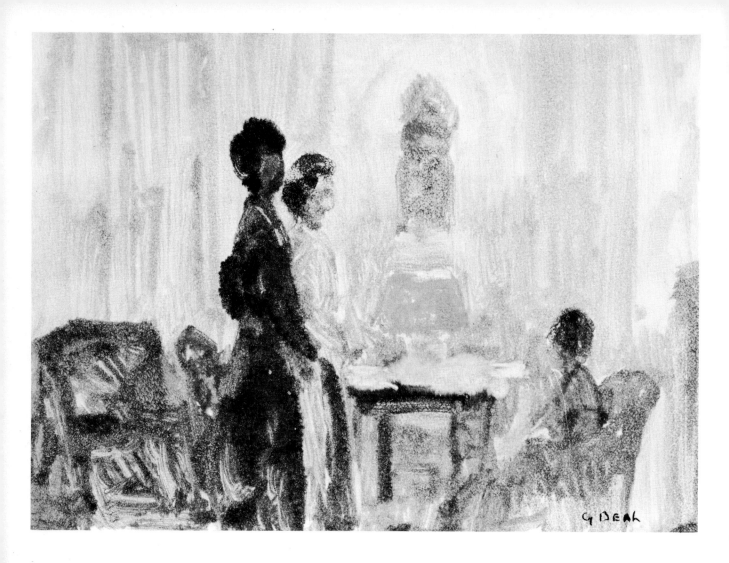

New York Interior by Gifford Beal
(1879–1956). The technique used is
free and loose, giving this mono-
print the appearance of a watercolor.
A series of silhouette-like figures has
been achieved by varying the
strength of the grays. The wash effect
was obtained by thinning down the
ink. (Courtesy, The Cleveland
Museum of Art, Mr. and Mrs. Lewis
B. Williams Collection.)

16

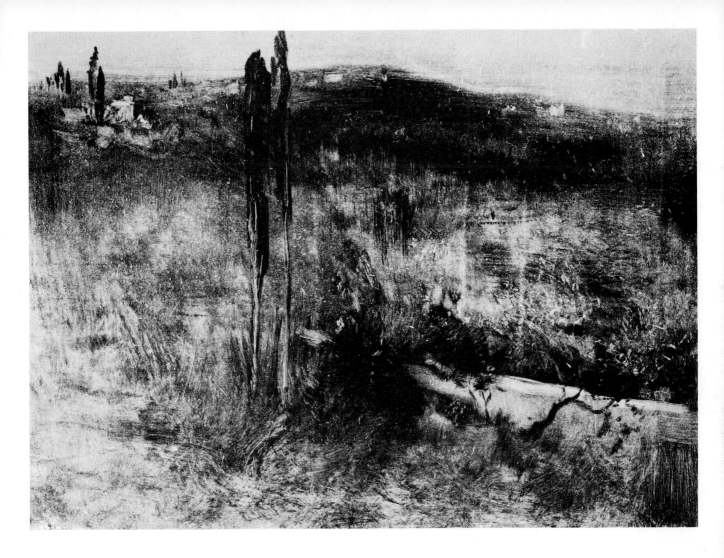

Italian Landscape by Frank Duveneck (1848–1919). The artist has wiped the ink from the plate with a rag in varying degrees of pressure and intensity. What remains is the impression of a haunting landscape. (Courtesy, Cincinnati Art Museum. Gift of Frank Duveneck.)

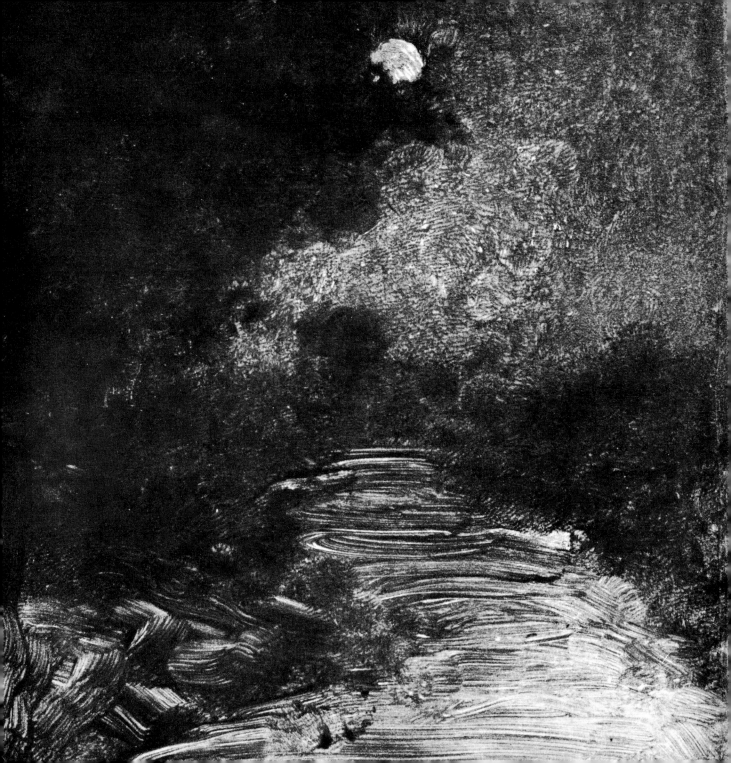

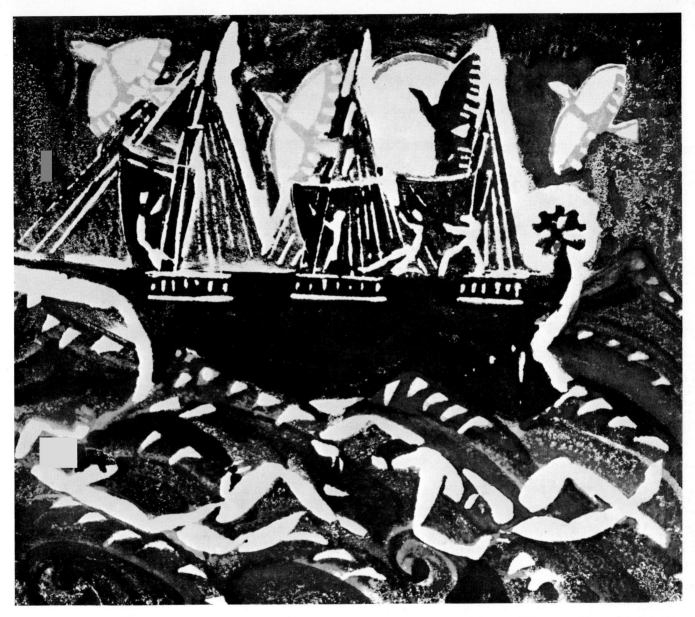

Opposite Page

Night by Ruel P. Tolman. The artist achieves a superb balance between dark and light in this monoprint. The white moon emerges as the dominant force in the composition, while the foreground (created with a few quick brush strokes) gives the effect of a moonlit road. (Courtesy, Smithsonian Institute.)

Ship by William Zorach (1887–1966). The grays, whites and blacks in this composition are playful, and all seem to be independent of each other. At the same time, they tend to overlap and to combine so that the overall scene is formal. Any section of this monoprint could be isolated and stand by itself as a separate picture. Aspects of stencil, woodcut and watercolor techniques are prevalent in this work, and yet, at the same time in its entirety it remains a monoprint. (Courtesy, The Cleveland Museum of Art. Gift of Mr. and Mrs. Ralph L. Wilson in memory of Anna Elizabeth Wilson.)

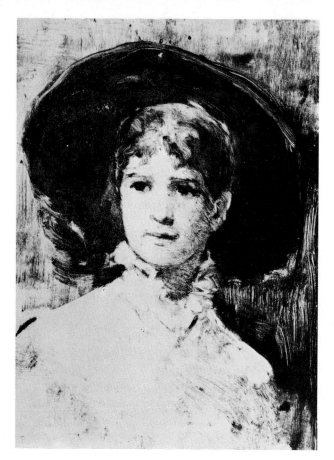

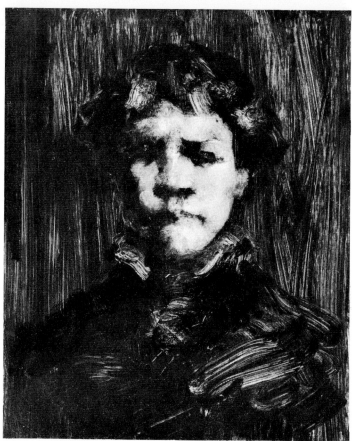

Head of a Girl in Large Hat by
Frank Duveneck (1848–1919).
(Courtesy, Cincinnati Art Museum.
Gift of Frank Duveneck.)

Head of a Boy by William Merritt
Chase (1848–1916). (Courtesy, The
Cleveland Museum of Art. Gift of
Mr. and Mrs. Ralph L. Wilson in
memory of Anna Elizabeth Wilson.)
These examples indicate how even a
very limited number of strokes can
produce variations in result. In the
Head of a Girl, the ink was allowed
to remain thick on the plate. In *Head
of a Boy*, the ink was thinned, and
the subject was rendered in the same
way as the former, only in this
instance a harder brush was used.

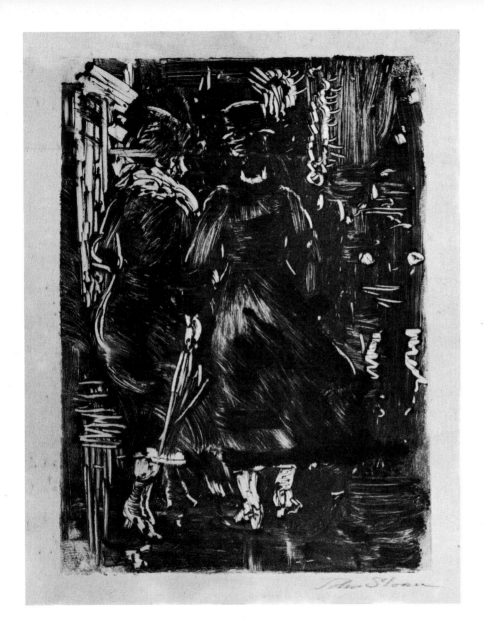

Rainy Night by John Sloan (1871–1951). There is a great dexterity of technique in this monoprint. The ink has been distributed to create a very wet effect, while a series of thick, thin, harsh and hard strokes serve to delineate the figures and to cast the mood of the scene. (Courtesy, The Cleveland Museum of Art. Gift of the Print Club of Cleveland in tribute to Mr. and Mrs. Lewis B. Williams.)

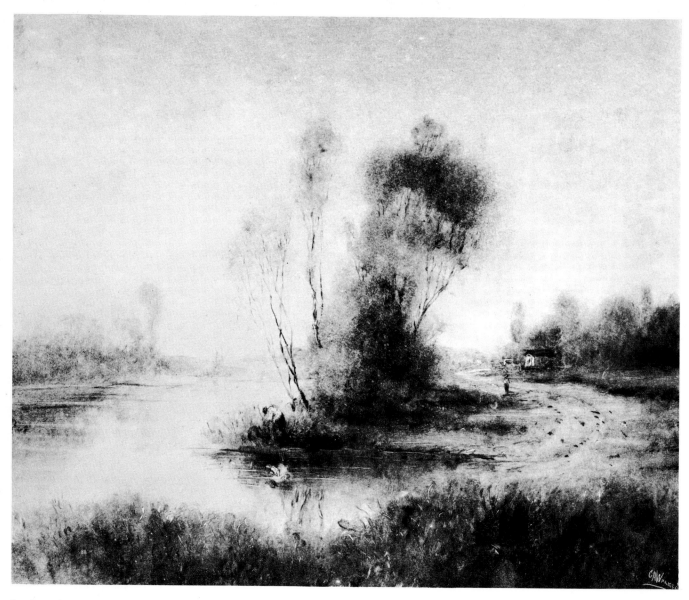

Landscape Study by Charles A. Walker. The landscape and the scene on the opposite page are similar in feeling, subject matter and choice of location, but the monoprint techniques used in both vary considerably. Walker has given his landscape a soft, almost mystical quality. Dahlgreen has made his scene stark, hard and very strong in appearance. Varying the amount of ink on the plate and the manner and pressure in which strokes are applied has much to do with the overall effects which result. (Courtesy, The Smithsonian Institute.)

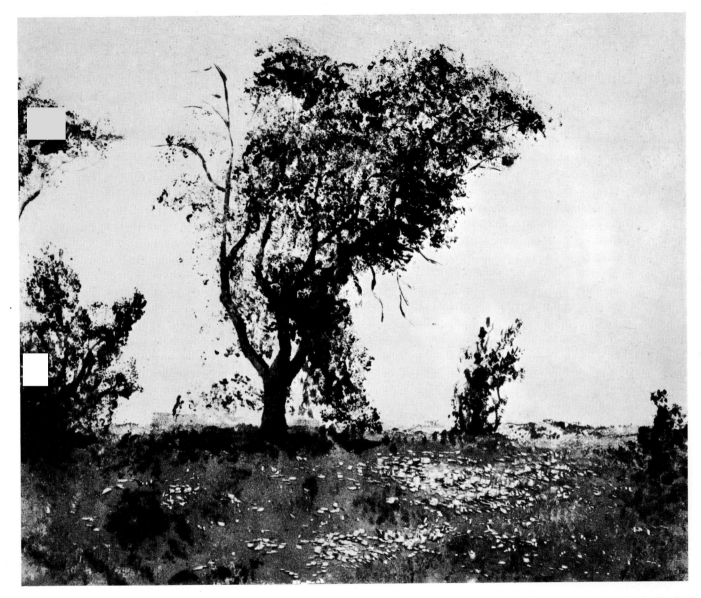

Summer, a monoprint by Charles Dahlgreen. (Courtesy, The Smithsonian Institute.)

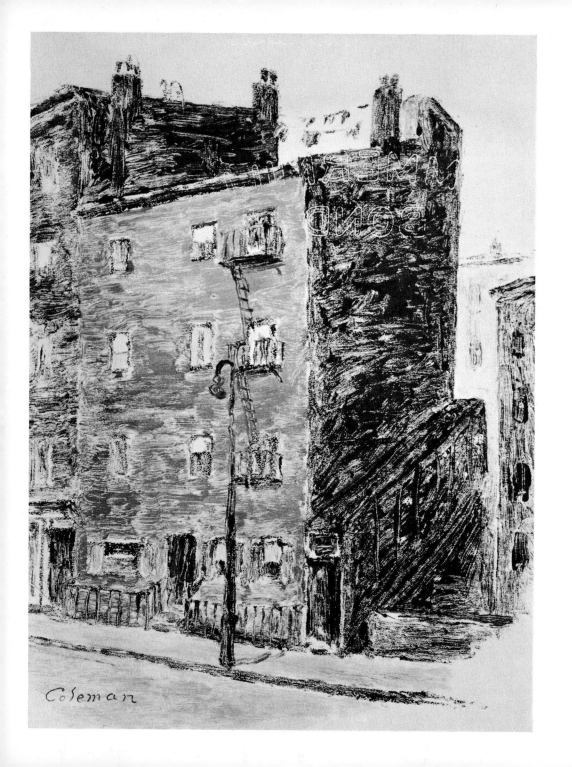

Old New York by Glenn
O. Coleman (1887–1932).
This quick rendering with
a few brush strokes
projects the feeling of a
cityscape. The pressure
used on the back of the
paper was light and even;
note how the paper
watermark has emerged
through the composition.
(Courtesy, The Cleveland
Museum of Art, Mr. and
Mrs. Charles G. Prasse
Collection.)

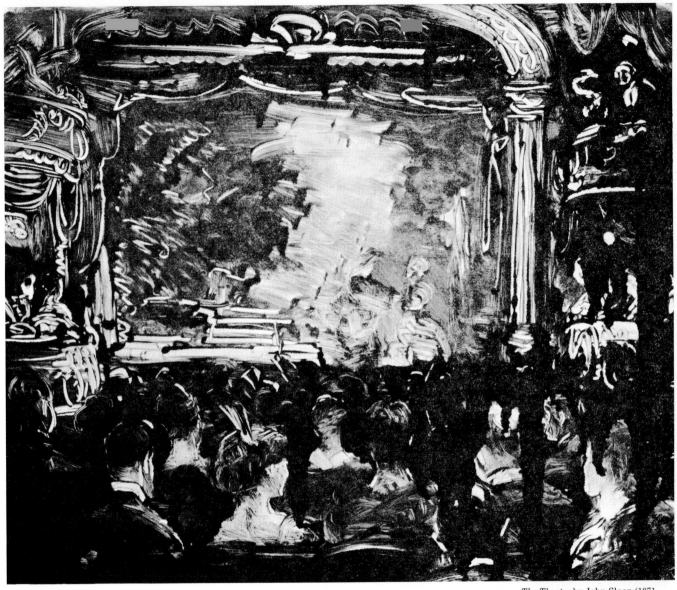

The Theatre by John Sloan (1871–1951). In this monoprint the soft, thin and merging quality of the audience is in stark contrast to the vibrant feeling which seems to be exploding on the stage. The artist has achieved this dramatic quality by his method of removing ink from the plate. (Courtesy, The Cleveland Museum of Art. Gift of Mr. and Mrs. Ralph L. Wilson.)

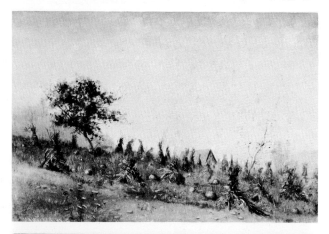

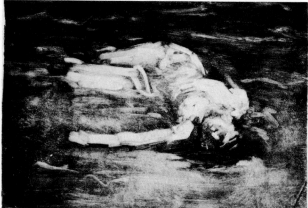

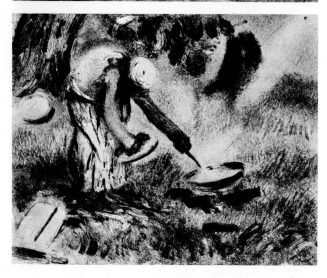

These three compositions by different artists on varying themes indicate the diversity of the monoprint technique. Walker has achieved a subtle pastel quality, and the feeling of autumn haunts his farm scene. There is a bold lithographic quality in Duveneck's *Floating Figure*. The strong white of the reclining figure seems to ride on the motion of the wavy background and yet in itself remains distinct. In Hart's *Man Stirring Contents of Frying Pan Over Fire*, the figure tends to merge with its background, while the entire composition has a brush and India ink quality about it.

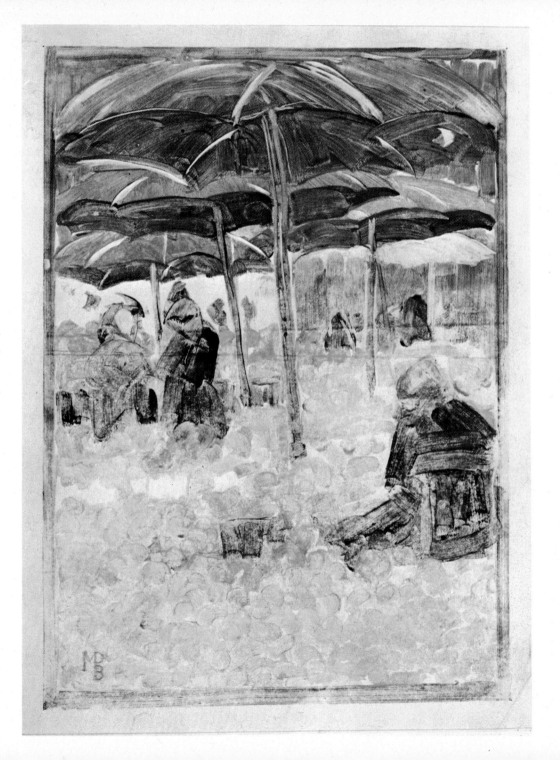

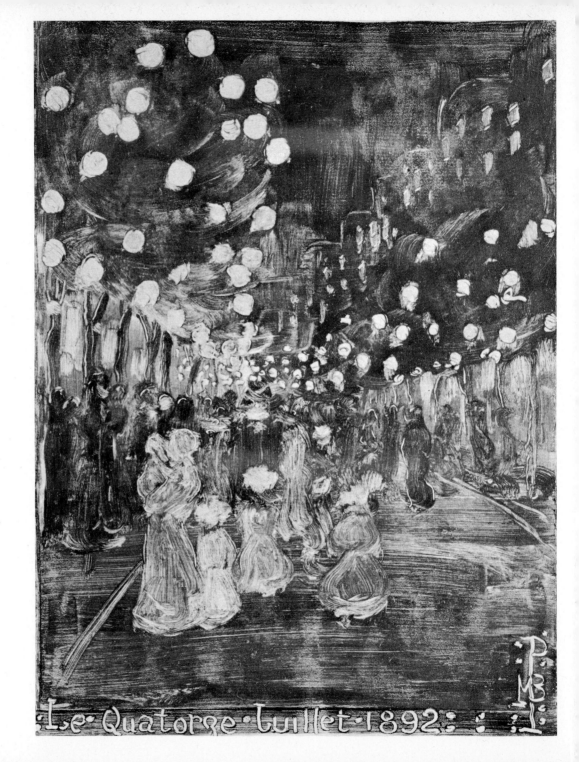

Bastille Day by Maurice B. Prendergast (1859-1924). Something of the great merits of the monoprint medium are conveyed in this composition depicting a scene in Paris on the 14th of July, 1892 (*Le Quatorze Juillet*), a day of national celebration. Prendergast, who was a monoprint master, has given definition to the crowd, the lights and the life of the city within the framework of his overall composition. (Courtesy, The Cleveland Museum of Art, Gift of the Print Club of Cleveland.)

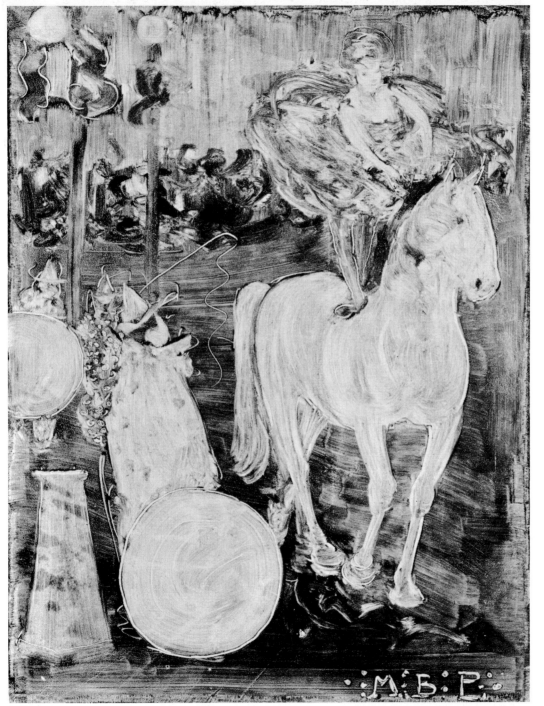

Bareback Rider by Maurice Prendergast (1859-1924). Prendergast has produced a contrasting scene to the night celebration depicted on the opposite page. Here we see a circus performance on a misty afternoon; there is a candlelight quality within the tent. Most of the figures were achieved by rubbing away the ink or paint in varying techniques. Note the swish effect used for the dress, the soft structure of the horse and the mixture of stroke techniques which make up the audience. (Courtesy, The Cleveland Museum of Art, Dudley P. Allen Fund.)

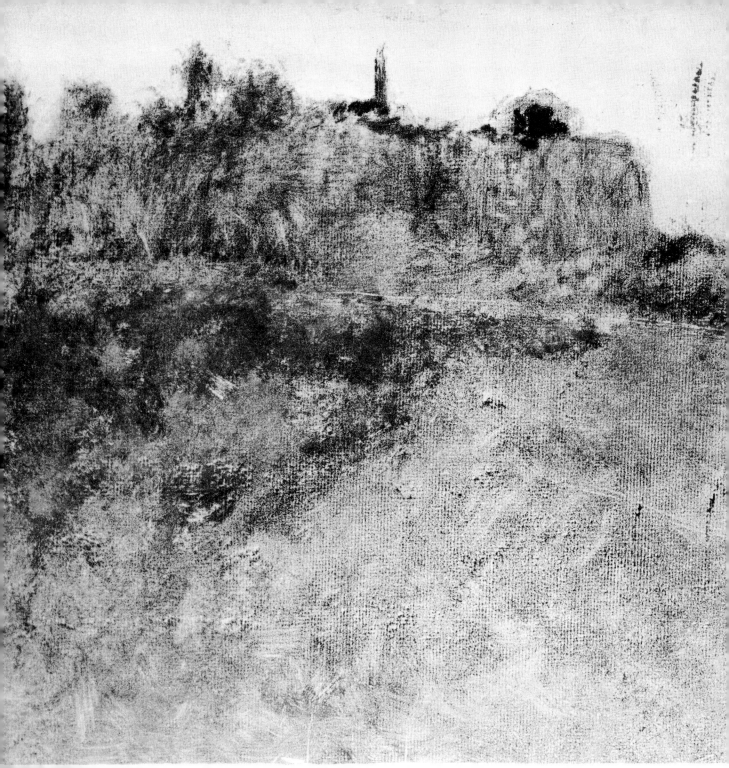

3.
Edgar Degas

It is felt by many that Edgar Degas
(1834–1917) carried the development of the
monoprint to its furthest possible limits.
Having been introduced to it through an
associate, Degas first experimented in the
medium to seek solutions to problems which
could not be fully explored with pencil or
brush. In the monoprint, he saw an oppor-
tunity to deal with unlimited shapes and to
play with qualities of light and shadow.

Some sources say that Degas executed
over 200 monoprints; others place the figure
at closer to 500. The number is not
important. Of greater significance are the
textures he created and his almost uncanny
ability to combine and blend successfully
other media with his monoprint composi-
tions. He brought tremendous recognition to
the monoprint as a medium which had been
more or less lost for several hundred years.

Degas apparently discovered a new kind of
freedom in the monoprint, using a rag or
cloth to draw his compositions instead of a
crayon or pastel stick. He also employed
matchsticks, his thumb, and practically any
instrument he could find to create texture
and to establish fields of shadow and light.
He found the medium personally challenging
and exciting, and often he deliberately chose
to work on a transparent plate so that he
could lift it up from time to time in order to
see how his monoprint was developing even
before it was pulled.

In a way, the monoprint medium to Degas
was somewhat of a means to an end, for he
sought every way possible to integrate this
work with other facets of his art. Thus it was
that his monoprints initiated a process that
took him in many other directions by adding
the color of many other media to his
compositions, particularly pastel. His
principal reason for developing his mono-
print techniques was to extend the life of the
unfinished sketch or drawing on which he
was working for as long as humanly possible.
Apparently, his paramount concern was
keeping the composition alive or in a state
of flexibility with rag and ink until he was
totally satisfied. His monoprints, in many
cases, were like guidelines or foundations to
some as yet unfinished work.

That Degas considered the monoprint to
be one of the most important skills within
his artistic repertoire is obvious from the
fact that at least a quarter of all his major
works in pastel – his principal medium of
expression – had their beginnings as mono-
prints. Monoprints therefore played an
integral role in the forces that fashioned his
tremendous creativity.

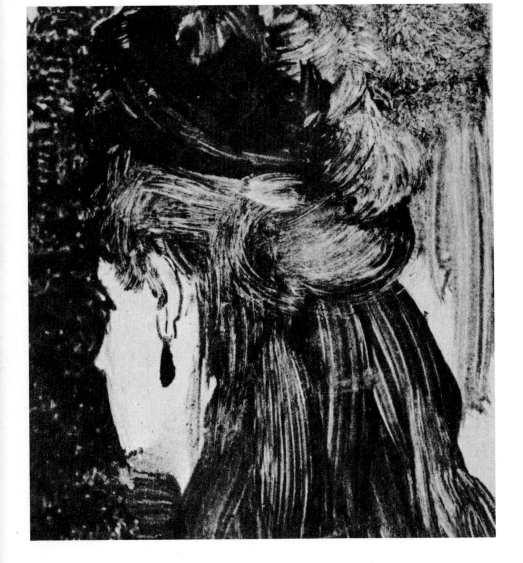

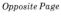
Le Jockey by Edgar Degas (1834-1917). At first, the viewer is conscious of an expanse of space achieved by the use of various ink techniques. Degas has placed dark areas on top of light areas, has merged patches of ink into each other and has scattered tufts of ink here and there to achieve an overall looseness within the monoprint. The equestrian figure appears to emerge from the center of the picture rather than from the distance. (Courtesy, Sterling & Francine Clark Art Institute, Williamstown, Mass.)

The Jet Earring by Edgar Degas (1834-1917). The swishing hair effect was achieved by thinning the paint or ink on the paper. (Courtesy, The Metropolitan Museum of Art, Anonymous gift in grateful memory of Francis Henry Taylor, 1959.)

Pages 34 and 35

Three Ballet Dancers by Edgar Degas (1834-1917). A spectacular use of the monoprint medium by a master artist. The entire drawing is facile in its rendering, and still it conveys speed, motion, light and the drama of the theatre. The movement of the dancers is achieved by taking away ink from the plate. (Courtesy, Sterling & Francine Clark Art Institute, Williamstown, Mass.)

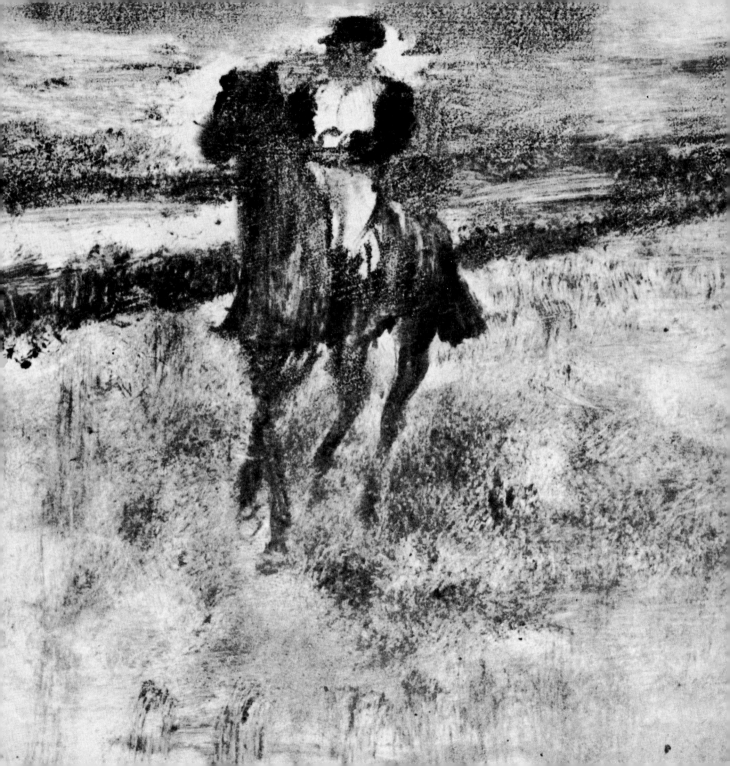

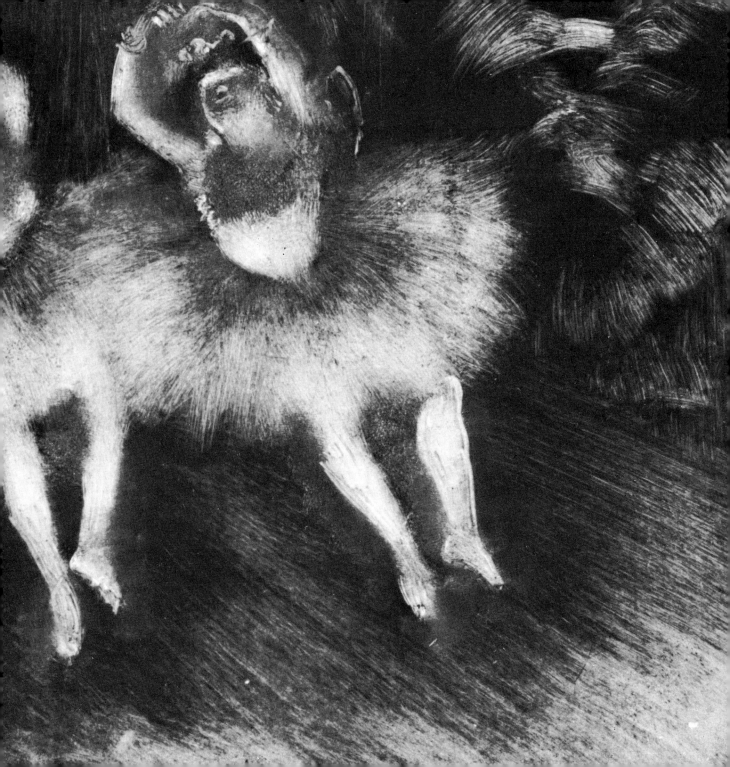

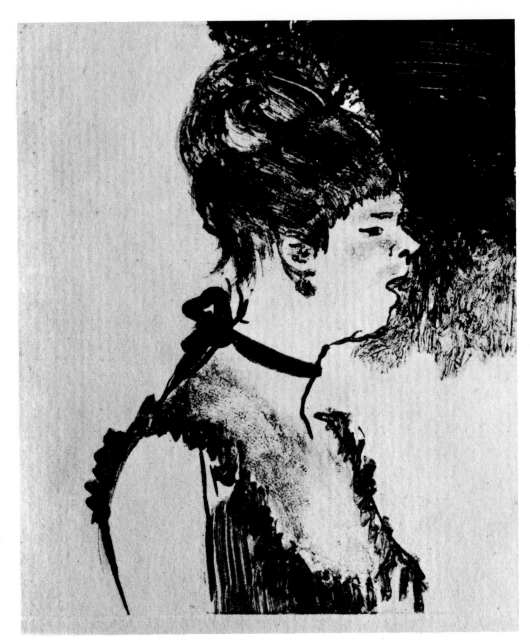

Café Concert Singer by Edgar Degas (1834-1917). In this monoprint and in the *Portrait of a Woman* on the opposite page Degas again displays his tremendous versatility with the medium and his full understanding of monoprint techniques. He plays lines against textures and washes against pure inks to achieve outstanding effects (Courtesy, The Art Institute of Chicago.)

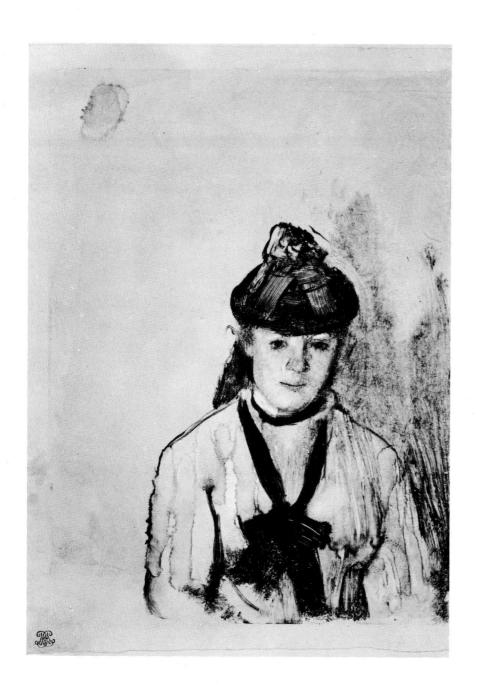

Portrait of a Woman by Edgar Degas
(1839-1917). (Courtesy, The Art
Institute of Chicago.)

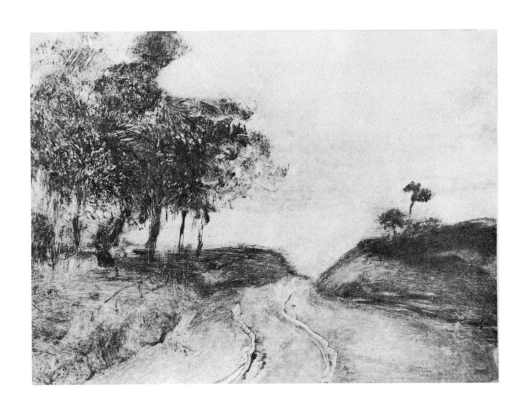

The Route by Edgar Degas
(1834-1917). By rubbing away ink,
with a rag or piece of cotton, by
erasing, and by creating ink washes,
Degas plays light against dark areas
to achieve an exquisite and delicate
watercolor effect. (Courtesy,
National Gallery of Art, Rosenwald
Collection.)

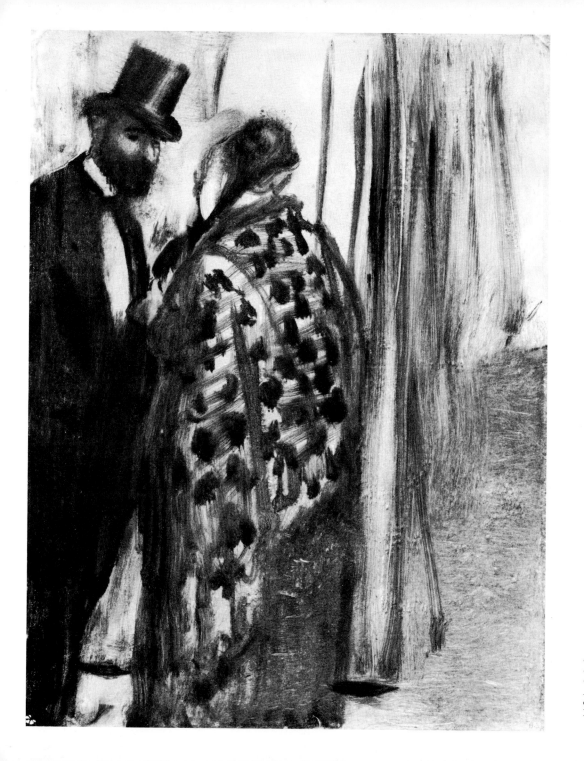

39

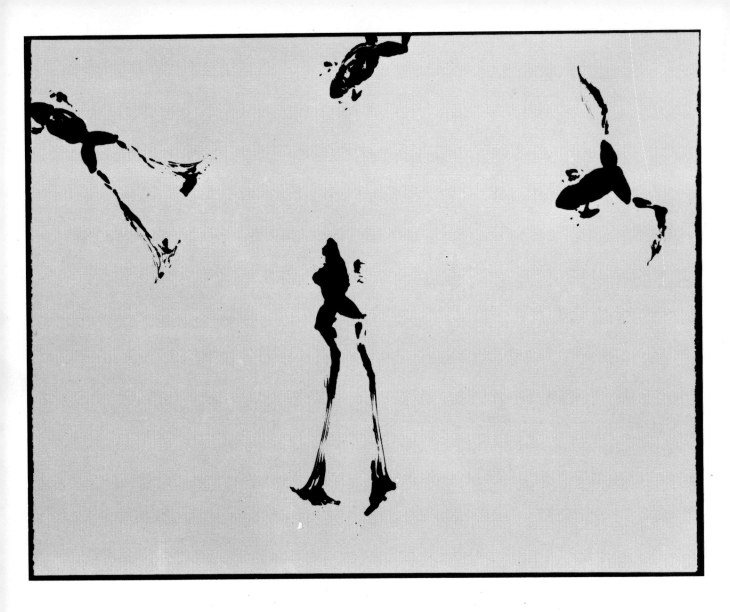

An untitled monoprint by Gordon Rayner. The floating figures appear
almost like the ink blots of a Rorschach test. The ink was dabbed onto the
plate and pulled down with a brush before the paper impression of it was
taken. This example shows that the entire plate need not be covered with
ink; ink can be applied only in the area needed for drawing. (Courtesy,
Canada Council and Dept. of External Affairs, Ottawa. Photograph:
John Evans Photography Ltd.)

4.
Master and Contemporary Monoprints

Among the masters of monoprint are Henri Matisse (1869–1954), whose dozen or so monoprints executed in 1913 and 1914 consisted of fine, economical white lines against pure black backgrounds. Quite the opposite are the monoprints of Paul Gauguin (1848–1903), whose work in the medium was strong and most personal. In his monoprints, Gauguin used both pattern and texture with much dexterity, often adding color to his finished composition. Many times his monoprints were experimental; he would often give them an intentional blurred and off-register effect which some describe as primitive yet at the same time highly original.

Early in the century and again in the 1920s, Pablo Picasso (1881–1973) turned to monoprints as did Georges Rouault (1871–1958). In either instance, the medium apparently held no lasting fascination, and

their works in this field, though highly interesting in many instances, lack the dynamism that they were able to evolve in other media. On the contrary, Marc Chagall (1887–) has been able to give his monoprints much of the warmth, richness and charm he transmits with brush, color and canvas.

There is a formidable group of artists in the United States and Canada today working in monoprints with both dramatic and dynamic results that are spearheading the development and popularization of the medium in this decade. Foremost of these is Matt Phillips, artist and Chairman of the Art Department at Bard College, New York. Phillips, who has worked extensively in monoprints, has written numerous articles and arranged a number of important monoprint exhibitions which have served to bring the medium back to public attention.

Milton Avery has also done much to popularize monoprints through a number of important one-man exhibitions that, in addition to showing his unique talent and imagination in the field, served to illustrate to others the great and often unexplored potentialities of the medium.

We have tried to include in this section reproductions of the work of as many monoprint artists of today as possible – Joseph Solman, Fritz Blumenthal, Richard Andres, Nathan Oliveira, Seymour Chwast, Fred Otnes and others. But naturally the limitations of space have made it impossible to include examples of the work of such fine monoprint artists as Harold Town, Helen Frankenthaler, Adja Yunkers, James Fitzsimmons and more, all of whom, through their talent and eagerness to experiment and explore, have given the monoprint the strongest lease on life it has had since the days of Degas.

Masquerade, a monoprint by Richard
Andres. (Courtesy, The Cleveland
Museum of Art, Purchase, Silver
Jubilee Treasure Fund.)

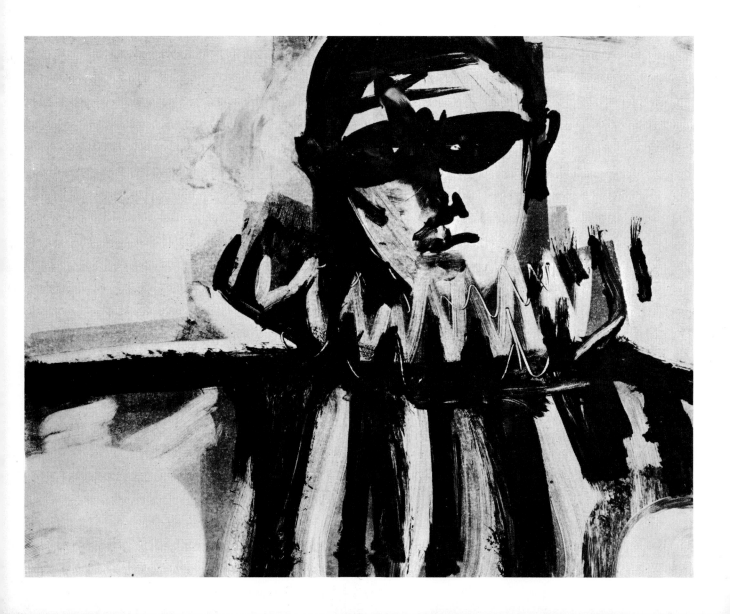

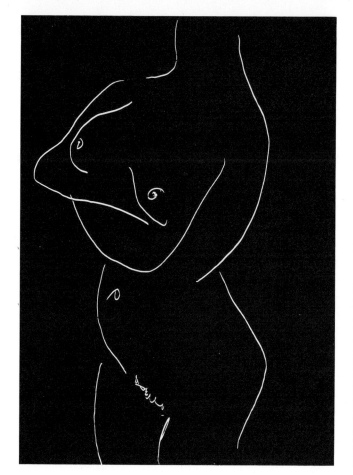

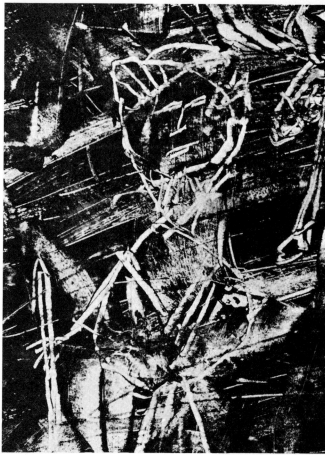

Torso, Arms Folded by Henri
Matisse. (1869-1954). Matisse's first
monoprint has the quality of an
etching. The thin but confident lines
were scratched into the inked plate,
the paper was applied over it, then
rubbed and pulled to produce this
monoprint. (Courtesy, Museum of
Modern Art, New York.)

*Deux Bédouins Avec Chameau
Entravé* by Jean Dubuffet. Using
lithograph ink, Dubuffet is playful
with his shapes, forms and figures
and, at the same time, conscious of
the paper texture. All of these
qualities merge to create a beautiful
overall monoprint. (Courtesy,
Catalogue des Travaux de Jean
Dubuffet; Jean-Jacques Pauvert,
Editeur, Copyright 1966.)

43

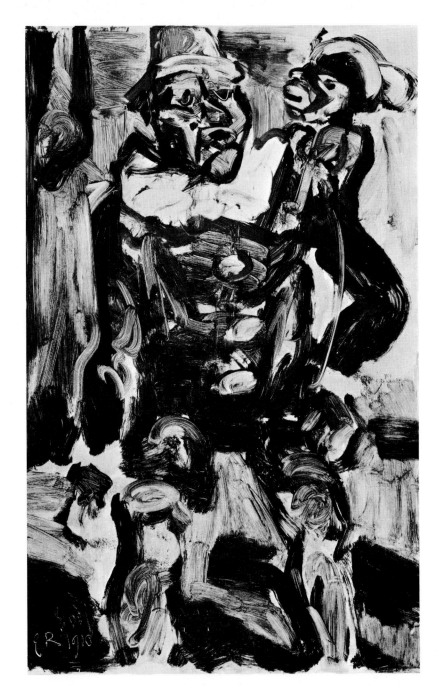

Clown with Monkey by
Georges Rouault
(1871–1958). The artist has
used brush strokes in
washed or diluted ink to
produce a highly
dramatic monoprint.
(Courtesy, The Museum
of Modern Art, New York.
Gift of Mrs. Sam A.
Lewisohn.)

Opposite Page

Four untitled monoprints
by Marc Chagall.
Chagall's great drawing
versatility comes through
in these monoprints with
richness of texture and
line and with a feeling of
rare sensitivity.
(Courtesy, G Gérald
Cramer, Editeur, Genève
Copyright 1966.)

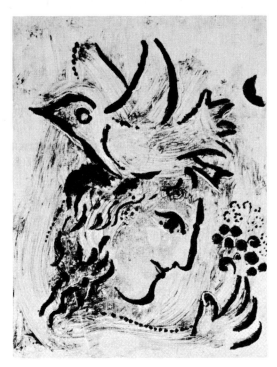

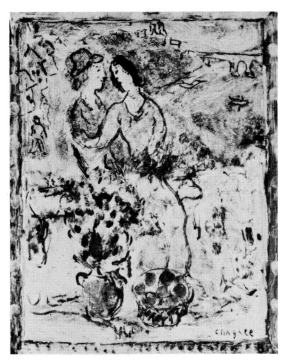

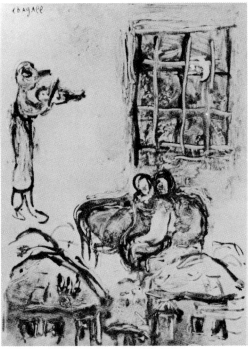

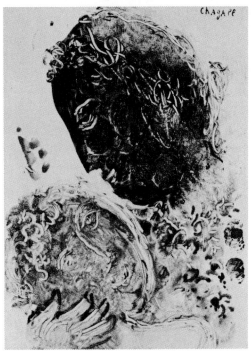

45

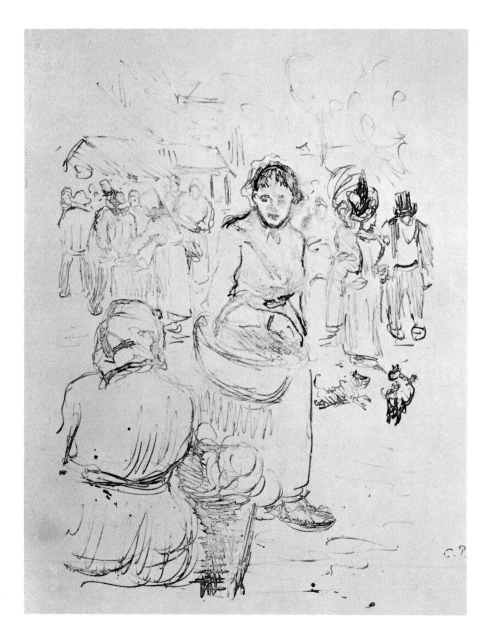

At The Market by Camille
Pissarro (1830-1903).
Another example of what
can be achieved with a
minimum of ink on the
plate. This monoprint
has the appearance of an
early master drawing in
sepia ink. (Courtesy, The
Cleveland Museum of Art,
Dudley P. Allen Fund.)

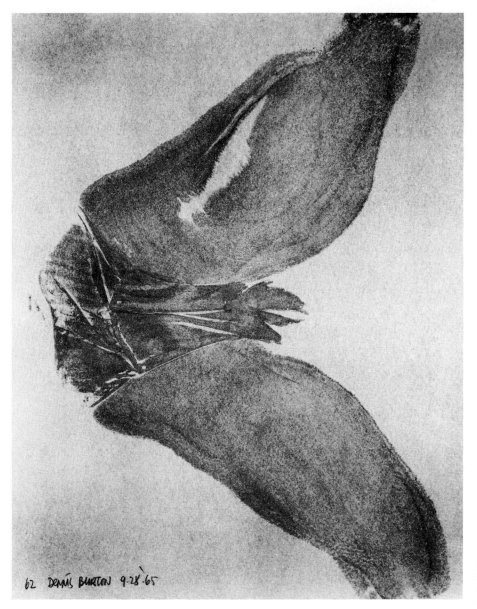

62 Dennis Burton 9·28·'65

An untitled monoprint by Dennis Burton. The background and textures in this composition have a very soft quality. A separate piece of paper was left on the plate before the impression was taken. (Courtesy, Canada Council and Dept. of External Affairs, Ottawa. Photo by John Evans Photography Ltd.)

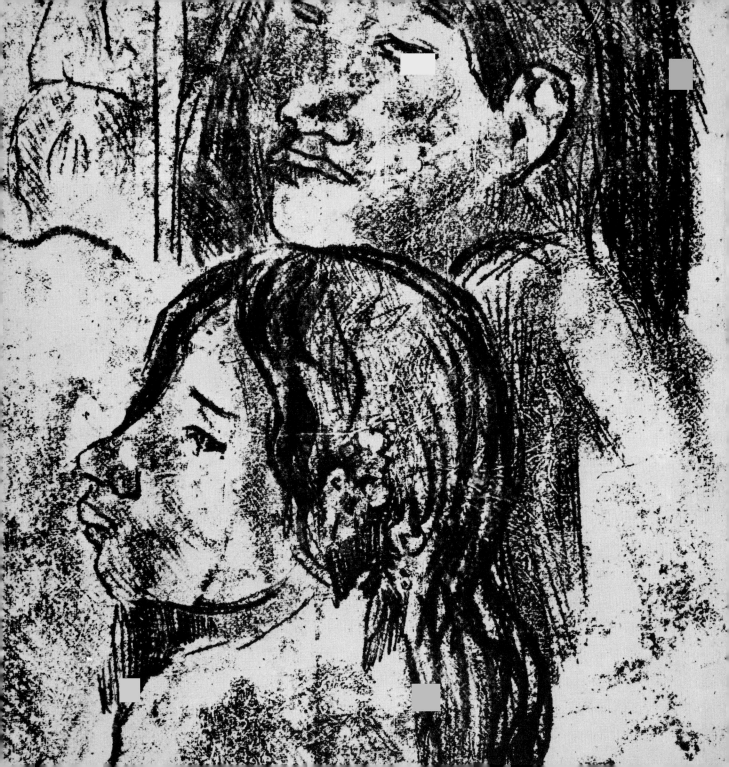

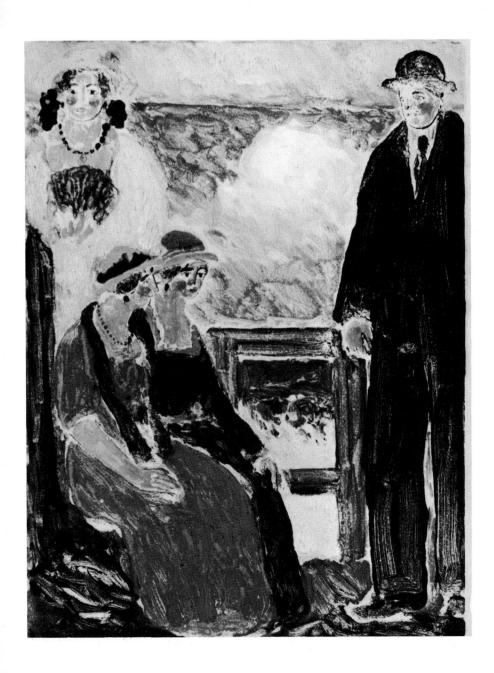

Opposite Page

Two Heads (detail) by Paul
Gauguin (1848-1903).
(Courtesy, Rosenwald
Collection, National
Gallery of Art,
Washington, D.C.)

Coney Island by Abraham
Walkowitz. A good
example of the use of
washes and the
effectiveness of thinning
the ink, all of which have
contributed to delineating
the figures and to
providing the background
of the sea. There is an
unusual vocabulary of
grays playing against
each other in this
forceful composition.
(Lent by Mr. and Mrs.
Monte Getler for
Smithsonian Institute
Travelling Exhibition,
"The Monotype: An
Edition of One".)

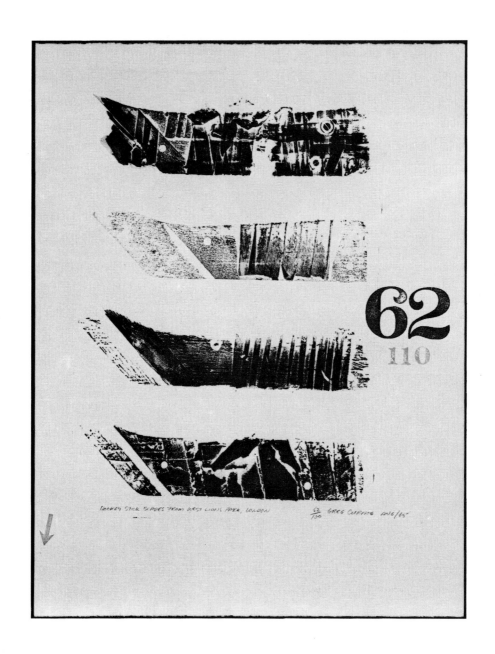

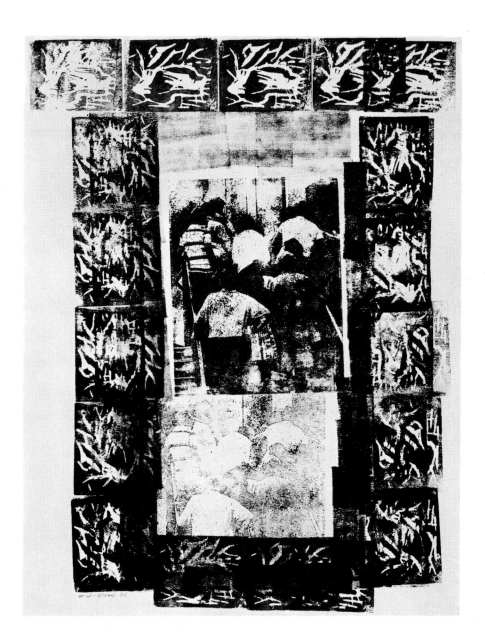

Opposite Page

Hockey Stick Blades from West Lions Park, London, Ontario, a monoprint by Greg Curnoe. By varying the thickness of inks and washes and by applying different pressures, the artist has produced four renderings of an actual hockey stick. (Courtesy, Canada Council and Dept. of External Affairs, Ottawa. Photograph by John Evan Photography Ltd.)

An untitled monoprint by William Ronald. The composition consists of two elements repeated over and over again in multiple-image style. (Courtesy, Canada Council and Dept. of External Affairs, Ottawa. Photograph by John Evan Photography Ltd.)

Colored Glass, a colored
monoprint by Fritz
Blumenthal. This
composition is almost
like an essay, each bottle
defining a different aspect
of the monoprint
technique. There are
combinations of light on
dark, gray on black,
white on white and grays
superimposed on grays in
this visual dictionary.
(Courtesy, Herbert E.
Feist Gallery, New York.)

Opposite Page

Pink Ms. by Norman
Laliberté. Before the ink
on this regular monoprint
was dry, patches of
watercolor were applied.

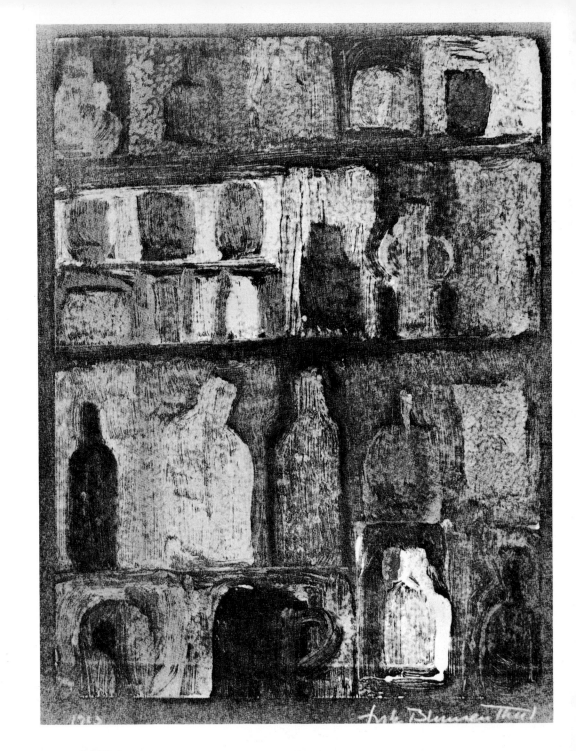

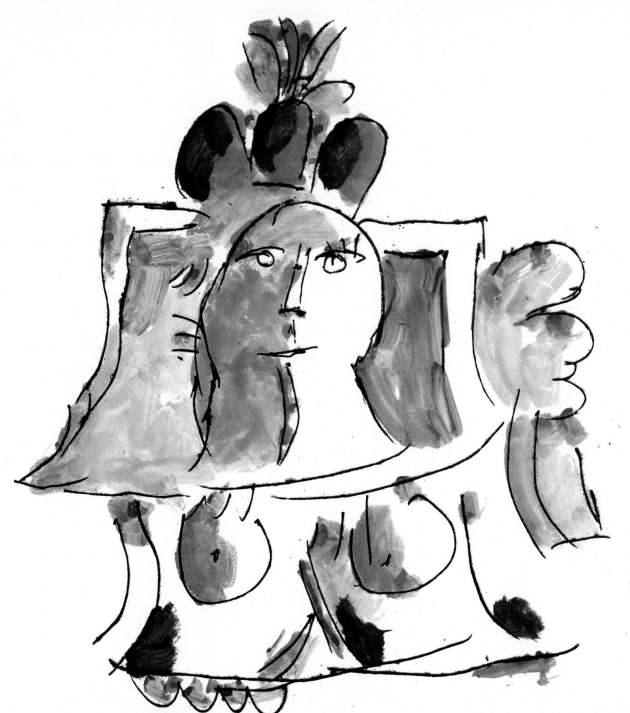

53

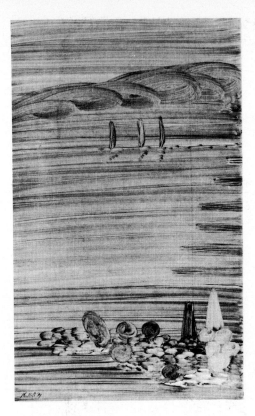

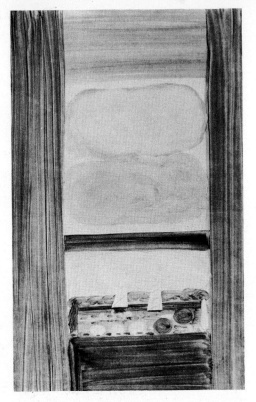

Left. Blue Beach. Right. The Open Window. Two monoprints by Matt Phillips. In *Blue Beach,* a variation on Whistler's nocturnes lies behind the composition. Strokes were done with fingers, brush and rags, while the paint was applied very thinly. (Courtesy, Open Window – Smithsonian Institute Travelling Exhibition: The Monotype: An Edition of One.)

Opposite Page

Moroccans in the Garden, a color monoprint by Matt Phillips. Printed by hand on Japanese paper with a tablespoon, the artist has captured something of the mood and feeling of the Moroccan landscape in his composition. Unusual drawing instruments such as a spoon produce their own individual line characteristics. (Photo courtesy the artist.)

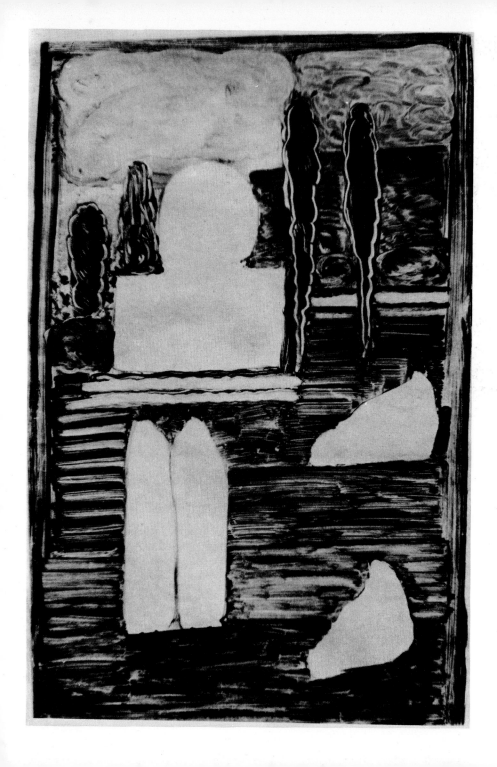

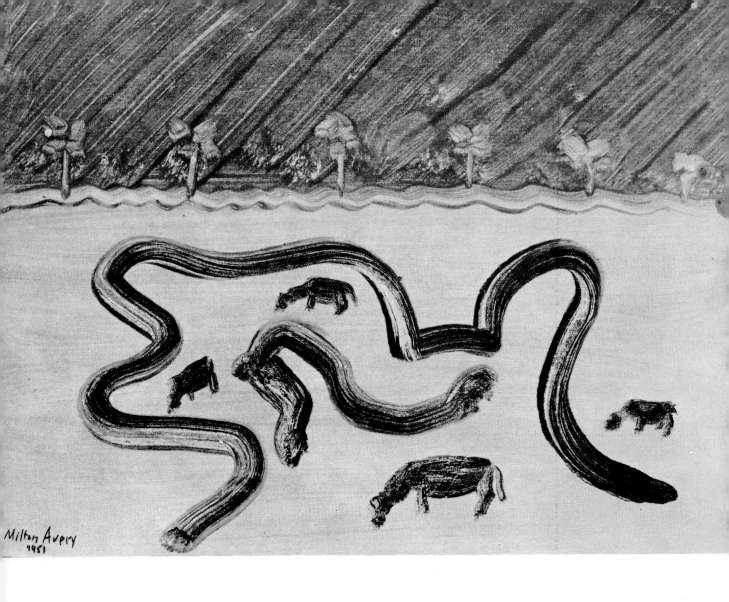

Opposite Page

St. John River by Milton Avery. (Courtesy, Smithsonian Institute Travelling Exhibition – The Monotype: An Edition of One – Lent by Mrs. Milton Avery.)

Above. Reclining Nude by Milton Avery. (Courtesy, Grace Borgenicht Gallery, New York. Photograph, William Rosenblum, Long Island City.)

In both of these monoprints the artist has used washed-ink techniques with considerable effectiveness. The large strokes have been applied rapidly with a brush. The feeling generated by the images is dictated, for the most part, by the artist's superb control of the washes.

57

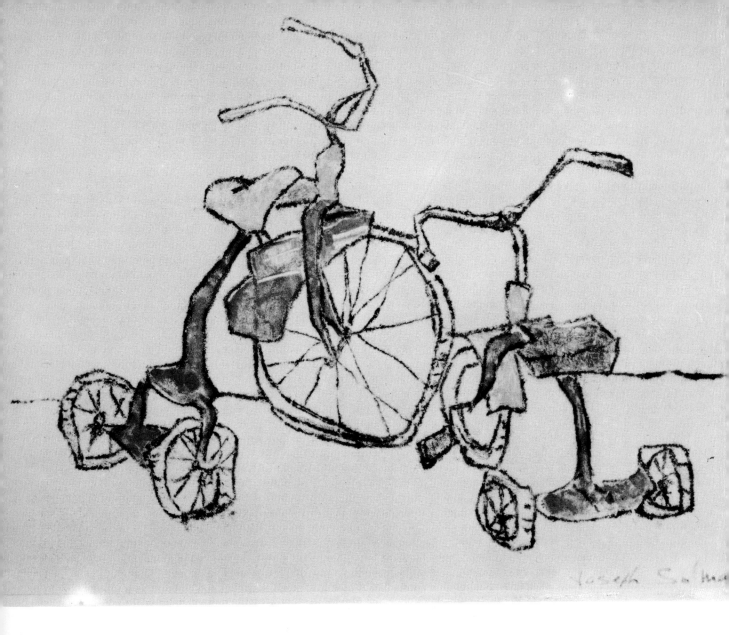

58

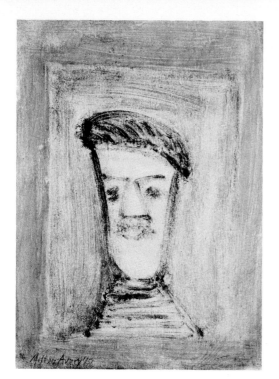

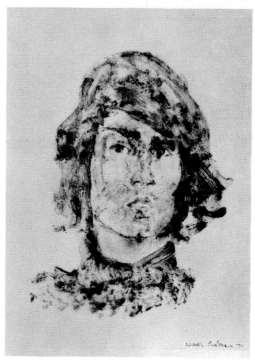

Opposite Page

Bicycles by Joseph Solman. In this color monoprint the artist drew the bicycles on paper and placed the drawing under glass. After making registration marks, color was placed on the glass. A sheet of rice paper was placed over the color when it was dry. The original drawing was then removed from under the glass sheet and placed on the register marks over the clear rice paper. The drawing was then traced and automatically transferred itself to the underside of the rice paper sheet. (Courtesy, Herbert E. Feist Gallery, New York.)

Above left

Self Portrait by Milton Avery. This is almost a "non-monoprint" because most of the ink has been removed from the plate. Still, the image emerges with force and clarity. Note the two distinct variations of the background. (Courtesy, Grace Borgenicht Gallery, New York. Photograph: Walter Rosenblum, Long Island City.)

Above right

Portrait of Paul by Joseph Solman. The artist painted a portrait of his subject directly onto a sheet of glass. A piece of rice paper, dampened with turpentine was placed over the glass and rubbed with the flat side of a wooden salad spoon, transferring the paint to the paper. (Courtesy, Herbert E. Feist Gallery, New York.)

59

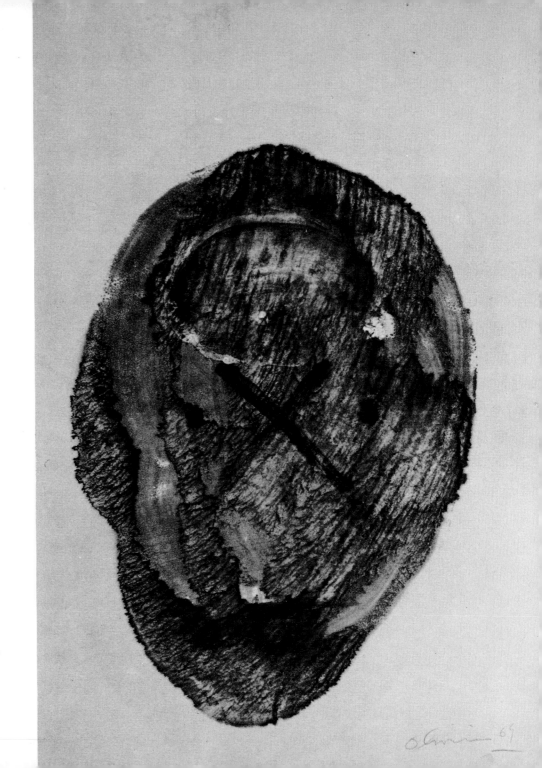

Mask No. 10 by Nathan Oliveira.
In this monoprint, it appears that
the plate was very wet and some
aspects of the mask emerged almost
accidentally. Still, the artist was able
to contain the final shape of the
mask and to minimally delineate its
features by adding eyes and an X to
represent other parts of the face.
(Courtesy, Terry Dintenfass, Inc.,
New York. Photograph: Walter
Rosenblum.)

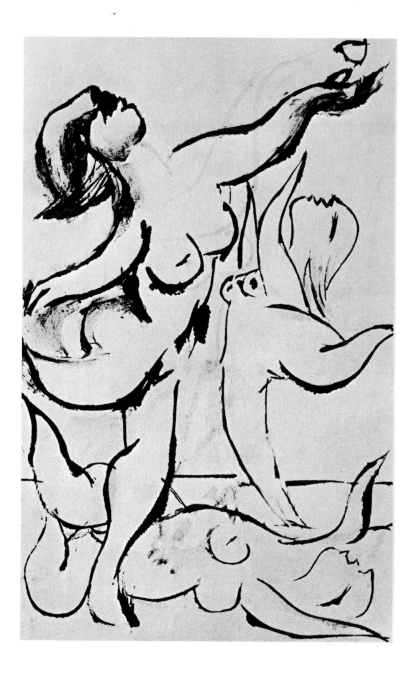

Three Dancers by Picasso. (Courtesy,
Editions Cercle D'Art, Paris.)

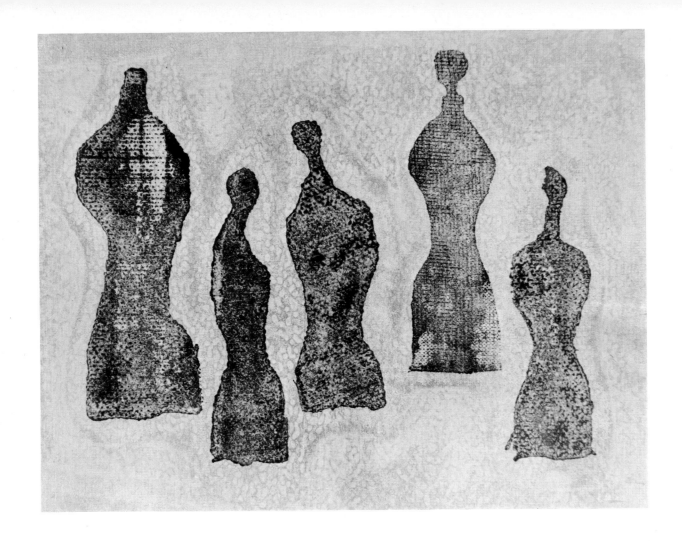

Five Personages by Fritz Blumenthal.
Oil pigments were used for painting
the background; the stained figures,
cut out of textiles to achieve texture,
were placed on top of the surface. The
monoprint was made on Japanese
rice paper. (Courtesy, Herbert E.
Feist Gallery, New York.)

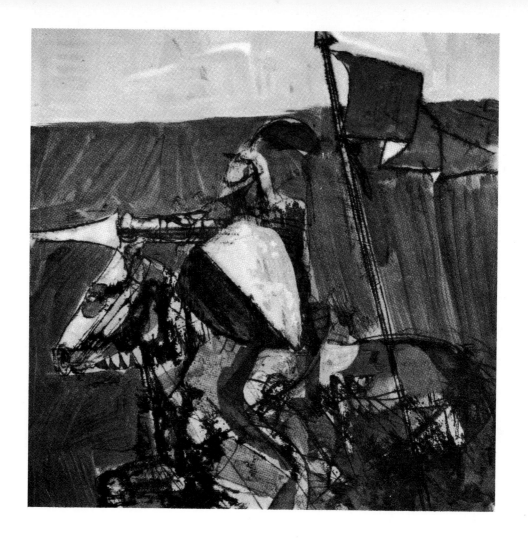

The Knight, a color monoprint by
Fred Otnes. The drawing was made
with a number of quick strokes
delineating the horse, rider and the
rider's flag, shield and spear. Color
was added to the composition after it
was pulled. (Courtesy, Tennessee
Gas Transmission Company.)

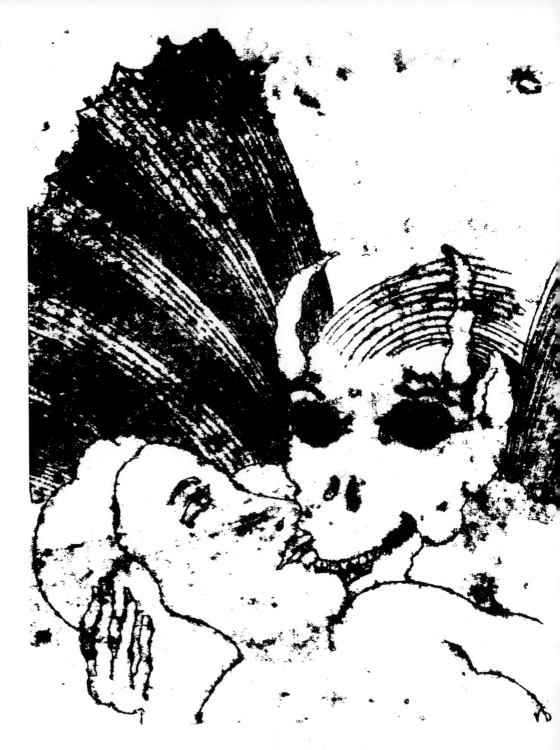

Monoprints by Seymour Chwast.
In these two compositions the artist
treats the monoprint technique as a
very contemporary medium.
(Courtesy, Push Pin Studios, New
York.)

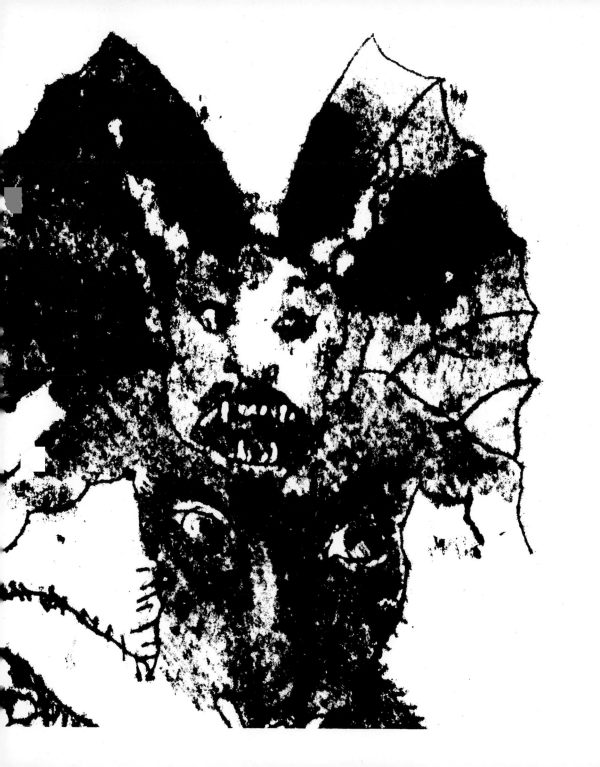

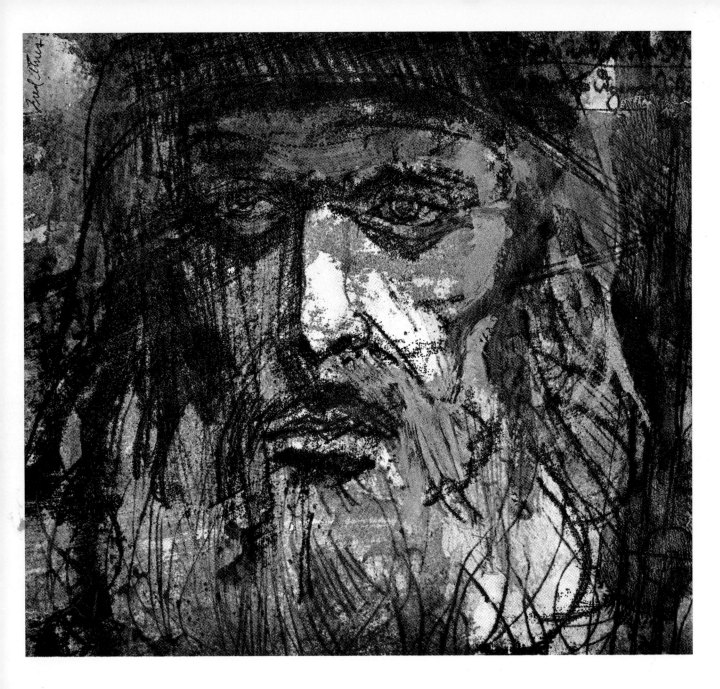

Leonardo da Vinci, a monoprint by
Fred Otnes. (Courtesy, Courier-
Citizen Company Printing and
Supply Division, Lowell, Mass.)

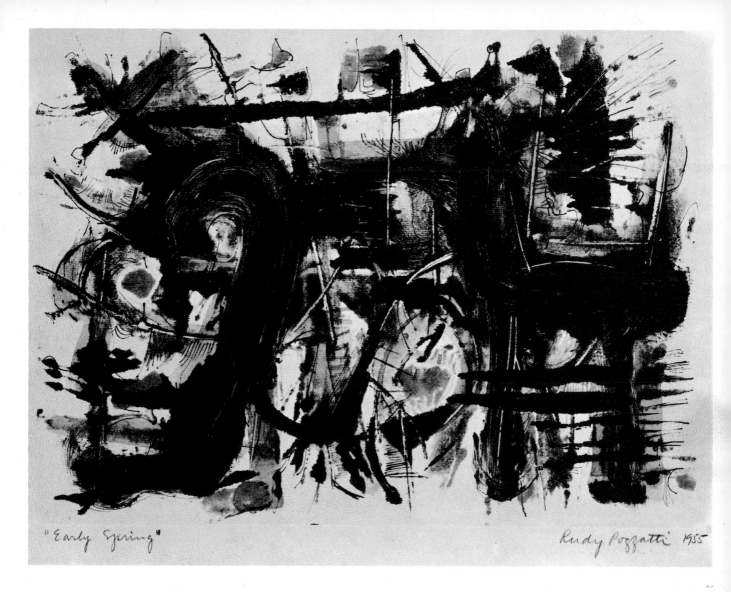

"Early Spring" Rudy Pozzatti 1955

Early Spring by Rudy O. Pozzatti. A quantity of black ink was applied very loosely to the plate. Carefully controlled lines were then added to the overall mass of ink. The finer lines in the composition were delineated on the completed monoprint. (Courtesy, The Cleveland Museum of Art, Gift of the Print Club of Cleveland.)

Liberation of the Adventurer, a series of relief monoprints by Dagmar Kocisova of Czechoslovakia. Impression of shapes from various found-metal objects are taken in monoprint fashion. The objects, the arrangements of which can be changed and altered to create different compositions, are coated or painted with printers' inks before the prints are pulled. (Courtesy the artist; photos by R. Kedro.)

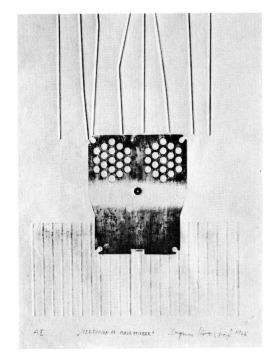

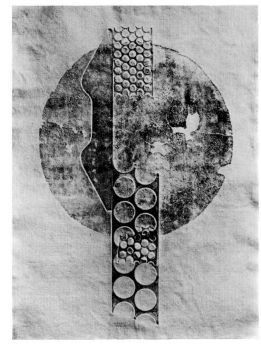

A Flat, from a series of color monoprints by
Barry Nelson. The artist rolls stripes of
colored inks on two empty plates and
successively prints on the same paper
from both plates. The inks from both
plates merge to create the image and
a great many transparent effects.
(Photo courtesy of the artist.) 69

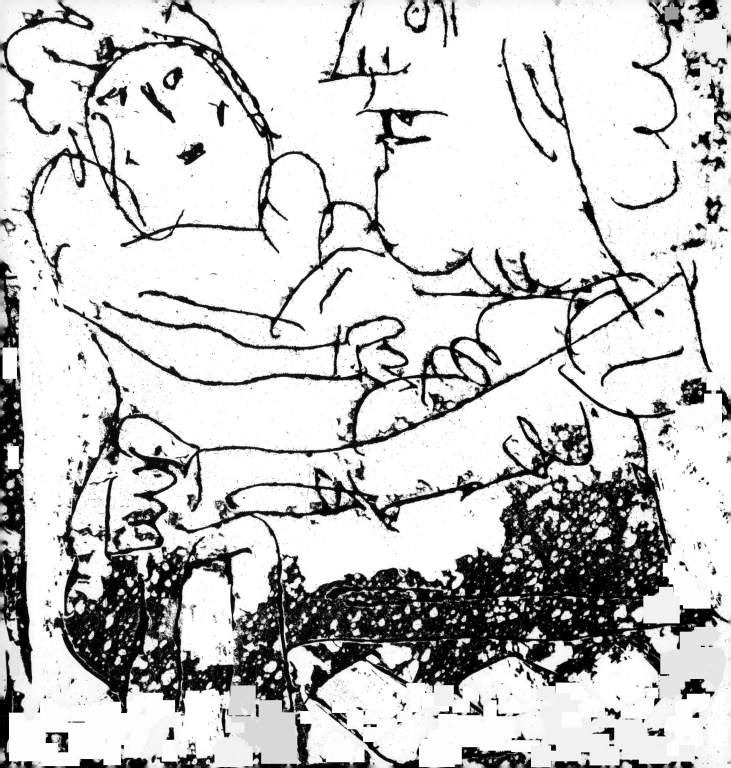

5.
Monoprint Demonstration

A number of monoprint techniques by Norman Laliberté are depicted in this section. Included are monoprints from drawings made on the back of the paper while the front or opposite side covers the inked area of the plate; monoprints pulled from compositions drawn directly on the inked surface; monoprints with backgrounds filled in by means of an inked roller or brayer; and monoprints made from the use of both the positive and negative elements of a cut paper stencil.

In discussing techniques in the medium, Laliberté accentuates the importance of experimenting and of working in a spirit of spontaneity.

"Drawing with different implements," he says, "sharp pencils, dull pencils, sticks, a steel stylus, a garden tool, the back of a brush, or even your thumb or finger – all produce different and many times exciting line qualities.

"Varying the pressure of your rubbing on the back of the print," he states, "produces many textural tones and qualities within your monoprint. Don't be afraid to experiment and to use unorthodox methods. There's a sense of discovery and anticipation in working with monoprints . . . a feeling that is unique to this medium alone. Your action makes ink and paper react, frequently in an unpredictable manner.

"At the same time, working with different kinds of paper and cardboard can be fascinating. Bond and tissue papers, shiny and dull finished papers, textured and colored papers, sheets of acetate, cardboard of various finish qualities and weights . . . all of these have different attributes which affect the results you achieve.

"Also you should explore the use of different colored inks and paints. There's no reason for working in black alone. Many printers have residue inks which they will be happy to part with, and you don't need much because even the smallest dab on your plate goes a long way. As long as you're willing to experiment," Laliberté contends, "the medium will continue to be exciting and fascinating to you."

A number of other techniques are discussed in the section illustrating Laliberté's monoprints, beginning on page 81.

The tools required for monoprints include a sheet of glass, aluminium, steel sheeting, plastic or any hard, clean and clear surface, brayer or printer's ink rollers of varying widths, scissors, razor blades, hard and soft brushes, gum erasers, pencils, nails, knives, and kitchen tools. It is best to have a multitude of implements available for drawing lines and rubbing, even those which you think may not be of use. You can use any ink, glossy or matte, black or colored. Also you should have a wide variety of paper: thick and thin, glossy, dull, acetate, light cardboards, corrugated board, Japanese and handmade papers, papers of various textures, and even cottons and other cloth materials which can be treated like paper. All of these contribute to the effects you will achieve. You will also need kerosene for thinning your ink and cleaning implements and hands when you are finished.

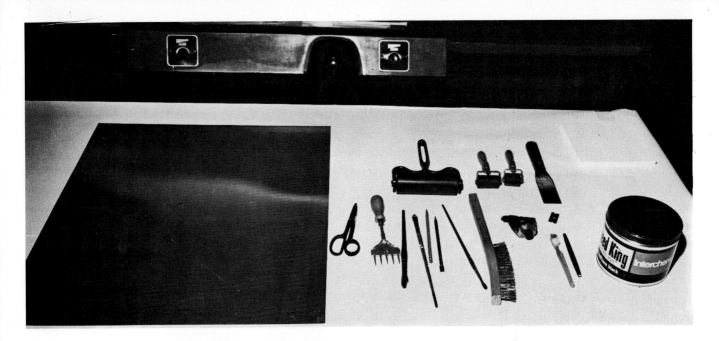

Tools and procedure
for monoprint
demonstration

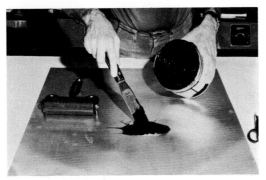

1. Place a small dab of ink on a plate.

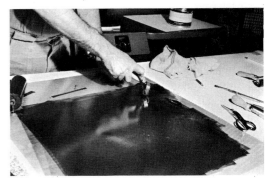

3. Roll ink as thinly and evenly as possible,
eliminating any heavy or coarse spots on
the plate.

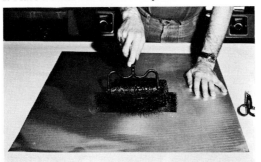

2. Spread ink on plate with a roller.

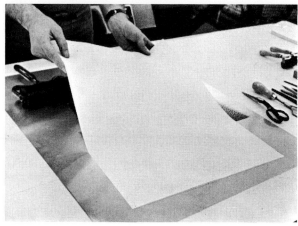

4. Place paper over inked area on the plate.

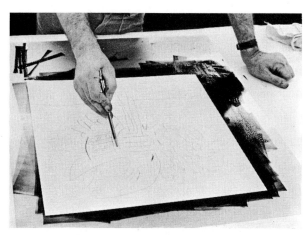

5. Draw your image on the paper. You can use a pencil, pen, brush, nail or stylus, gum eraser, your finger or thumb. Use as many different kinds of instruments as possible in making your drawing, for each produces its own distinct line quality. Also, the amount of pressure you apply will vary the quality of your line considerably.

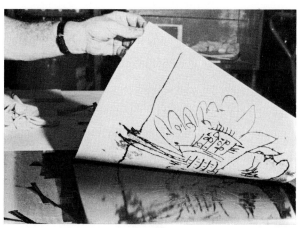

6. Completing the drawing. The paper is pulled. See completed monoprint on page 104.

73

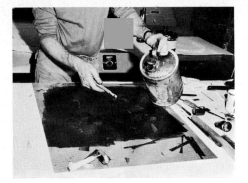

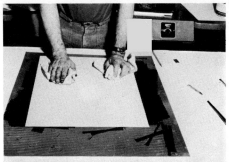

Opposite

The completed composition. You can pull additional monoprints; each one, however, will be lighter and lighter, and line effects will vary considerably with the usage.

Drawing the Monoprint directly on the Inked Surface:

1. A small amount of kerosene is added to the inked plate surface in order to give the monoprint diluted black and washed tone characteristics.

4. Paper is placed over the drawing which has been made directly on the inked surface. The paper is then rubbed with a cloth.

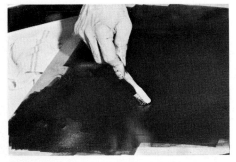

2. A toothbrush is an excellent tool to achieve a variety of effects.

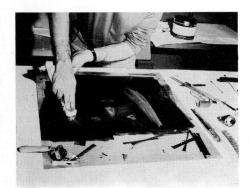

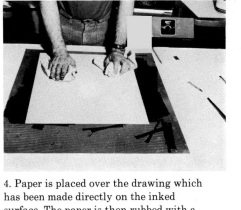

5. Pulling the monoprint.

3. A dry or wet kerosene rag is used to draw (or wipe away or displace ink) on the plate.

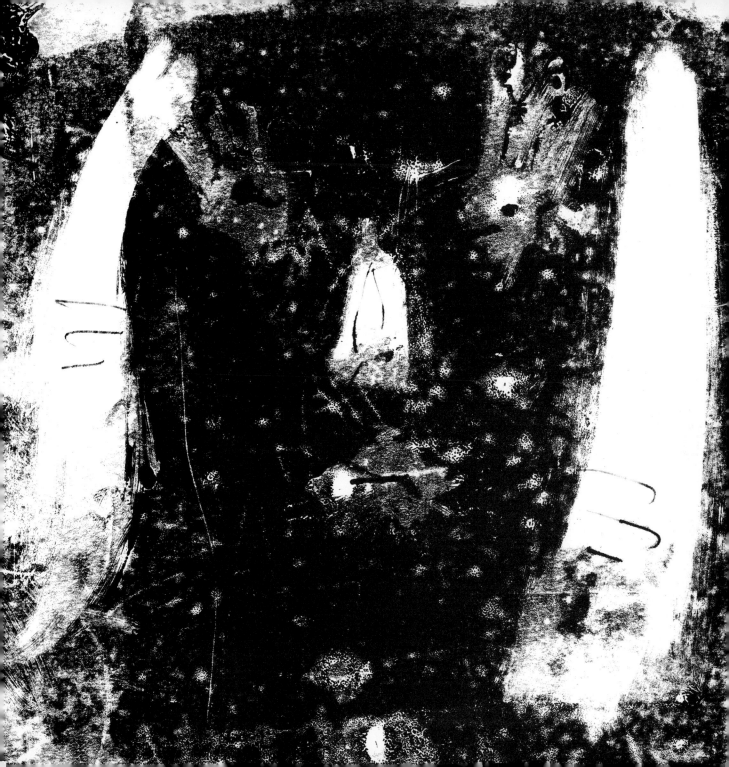

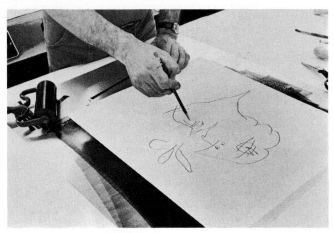

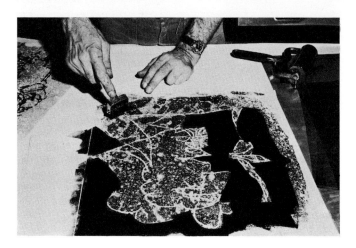

A monoprint was drawn on very thin paper and pulled. The background was filled in by applying ink with brayers of varying widths. The completed monoprint is on page 101.

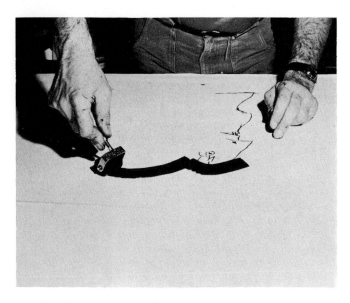

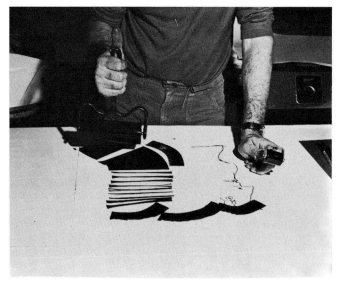

A quick profile was drawn on the back of a piece of paper and pulled. The rest of the head was completed by using brayers of varying sizes as drawing instruments. The completed monoprint is on page 103.

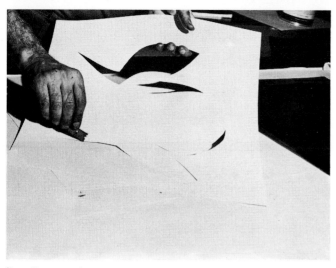

Stencil monoprints:
1. A stencil-like shape is cut from a piece of paper or thin cardboard. Stencils are cut here without preliminary drawing.

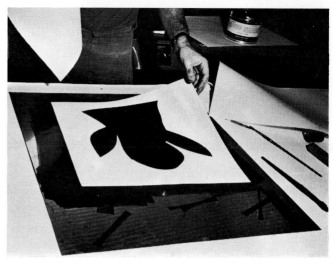

2. The stencil is applied to the wet plate. You can use either the negative or positive part of the drawing.

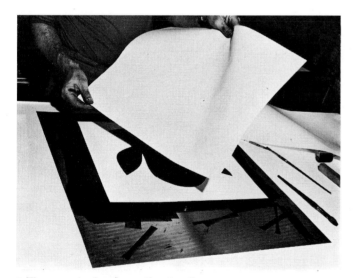

3. The paper is placed over the stencil onto the inked plate. Whatever is drawn on the back of the paper will appear only as a stencil monoprint.

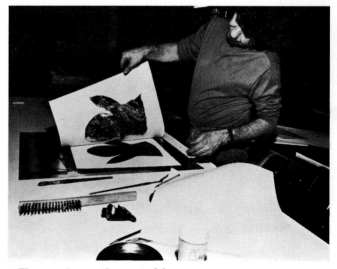

4. The negative or other part of the same stencil – an angel form or shape – is placed on the inked surface. See next page.

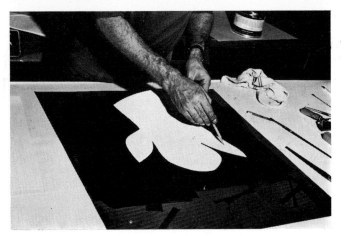

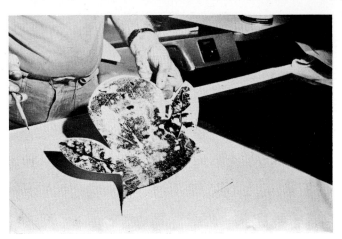

5. A drawing is made on the back of the angel form.

6. The form is pulled away from the inked plate. Note that a minimum amount of drawing was done on the paper. Most of the textures were achieved by the pressure applied on the back of the paper and the amount of ink residue on the plate.

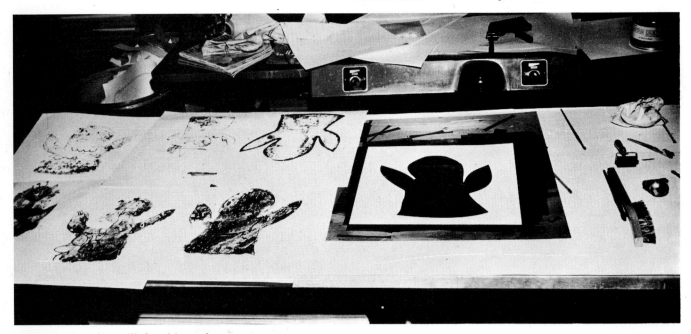

7. For selection of stencilled positive and negative variations see pages 86 and 87. (All photographs in this section by Hans Trevor-Deutsch. Special courtesy: Gordon W. Ros Ltd., Montreal.)

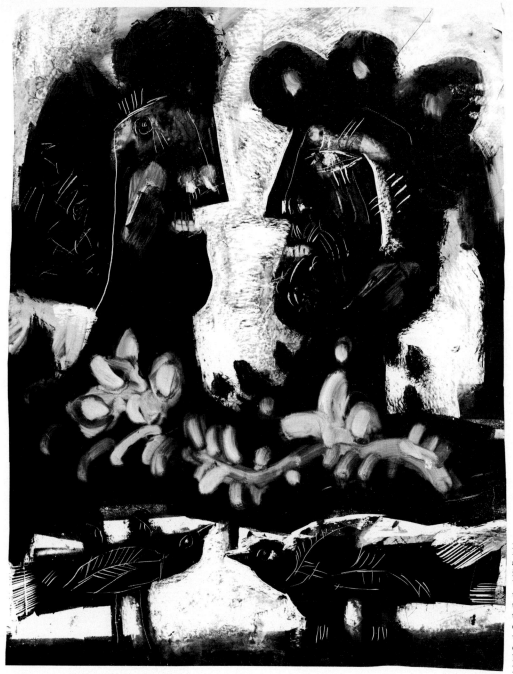

King and Queen with Birds, a monoprint by Norman Laliberté. The image is drawn with a roller on a piece of glass. A sheet of acetate is applied to the glass to receive the image. While the monoprint is wet, a toothbrush is used to create texture; cloth (soaked in turpentine) was used to create the softer texture of the flower. When the print was dry, the broadside of the razor blade was used to take away excess black and to define the figures. The fine lines within the heads and the birds were created with an X-acto knife.

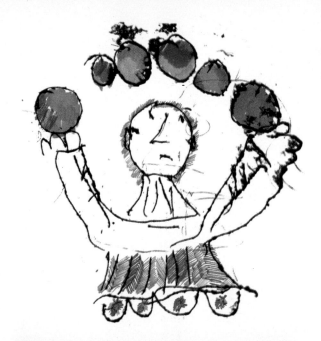

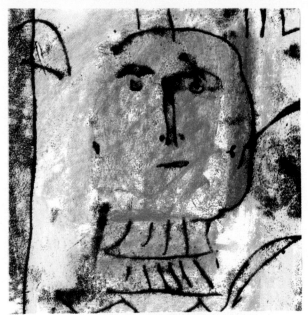

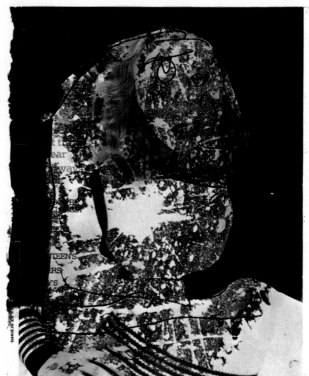

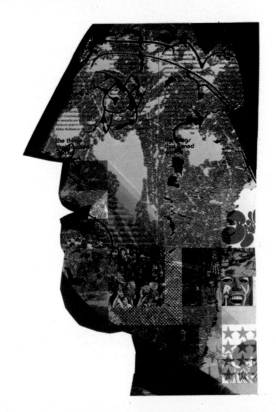

Four different treatments of the medium by Norman Laliberté. *Above, left. The Juggler.* The monoprint was drawn on a sheet of clear acetate. Magic marker coloring was added on a white paper background in the areas delineated by the lines on the acetate. *Above, right.* Easter: pastels were applied at random on a sheet of paper and a monoprint was then made on its colored surface, giving the image an accidental and loose form of coloring. *Below, left. Seventeen.* A page was torn at random from a magazine and placed on the inked plate. A pencil drawing was made on the back of the page and then pulled. The background area was filled in with a printer's roller. Note how the printed image from the magazine page emerges through the composition. *Below, right. Profile.* This monoprint is the same as *Seventeen,* except when the drawing was dry, a razor blade was used to cut out the profile.

6.
Monoprints by Laliberté

A number of monoprint methods and techniques are delineated in this section through the reproduction of work in the medium by Norman Laliberté. Included are:

The use of various tools. Use forks, knives, nails, garden tools, a metal stylus, pencils, brush handles and, in fact, any found implement to create varying line qualities when drawing your compositions. Even draw with your fingers! Don't be afraid to use items like the back of a spoon or flat sticks for rubbing the back of your monoprint.

Monoprints on acetate. Acetate has wonderful qualities with respect to ink pick-up and adherence. A monoprint on acetate lends itself to a number of different possibilities, including the coloring of an added paper background (visible through transparent sections of the monoprint composition) with watercolor, felt-tipped pens or even colored pieces or sections of paper.

Stencil monoprints. The possibility of working with both positive and negative parts of your paper cut stencil are truly unlimited. Don't forget the great effect achieved in working with multiple-image ideas.

Scratching and coloring into finished monoprints. Details within monoprint composition can be elaborated upon or further delineated by scratching with a sharp instrument and by adding color in any medium: pastel, dyes, watercolor, felt-tipped pens, and color pencils.

Monoprints on paper that has been pre-treated with color. Rub pastel or other color media in random patches on paper.

Drawing is done on the reverse side with color side placed over the inked plate.

Minimal monoprints. Produce a profile or a minimal drawing in the monoprint method; fill in background by applying ink with a brayer roller, washes or any other painting or drawing method.

In commenting on these techniques, Laliberté points out that the monoprint should not be considered as a preliminary art process to be completed in another medium.

"The monoprint," he says, "is a legitimate form of artistic expression in its own right. Exploring its full potentialities is a true challenge to the artist's imagination and ability to cope with a medium which always is lively and many times most surprising in its spontaneous results."

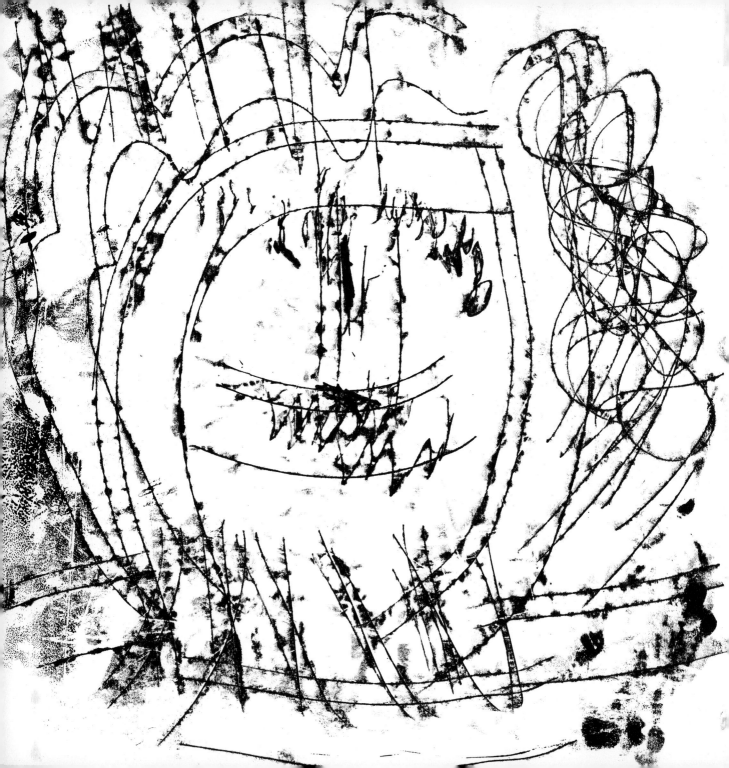

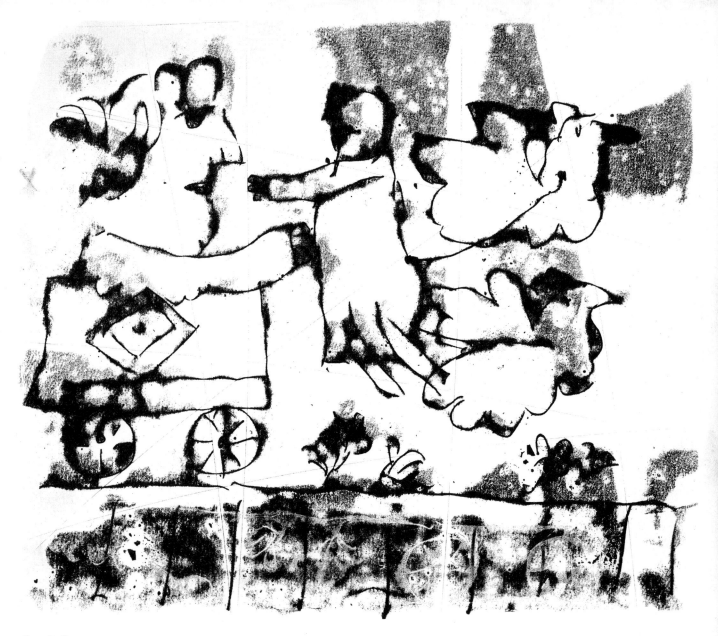

Opposite Page

Knight. A garden fork tool was used to make the drawing. The drawing was made very rapidly because each stroke of the implement created five lines of more or less the same quality.

Venus. An extremely thin coat of ink was left on the plate; a sharp pencil was used on a very heavy coated paper stock, the varying of pressure causing the fine or dark line qualities.

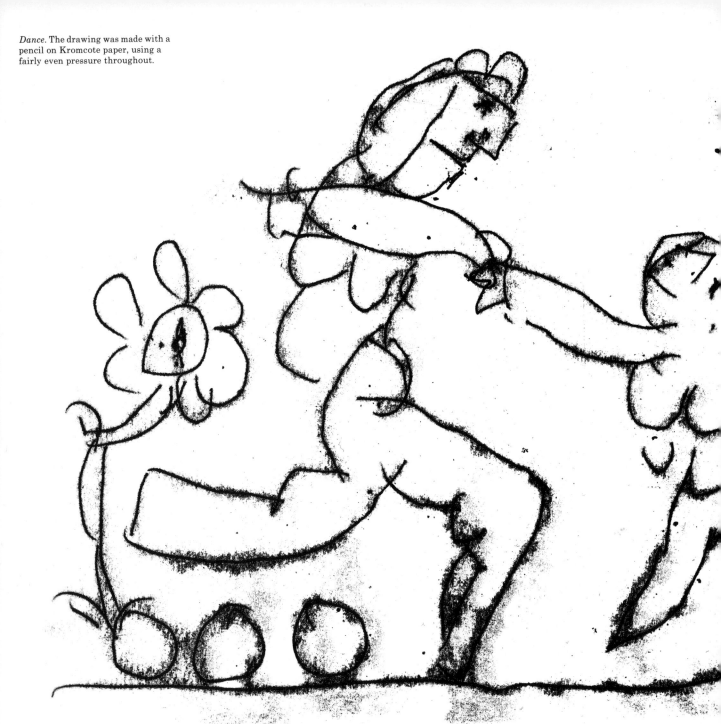

Dance. The drawing was made with a pencil on Kromcote paper, using a fairly even pressure throughout.

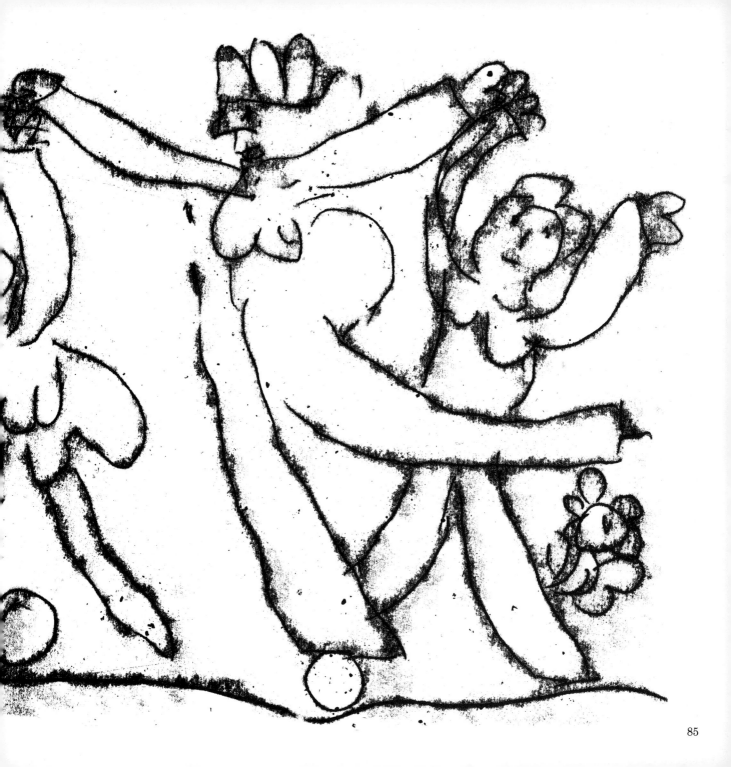

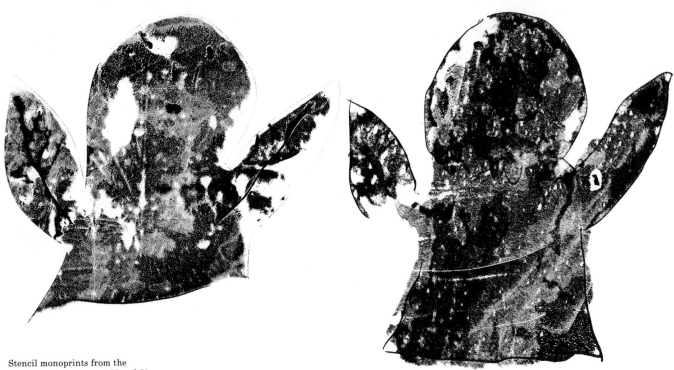

Stencil monoprints from the
demonstration on pages 77 and 78.
Shown are four different methods of
completing the angel, some heavy,
others light, some with varying
pressures. In some instances,
quantities of ink have been rubbed
away, lines have been added to the
pulled monoprint or both.

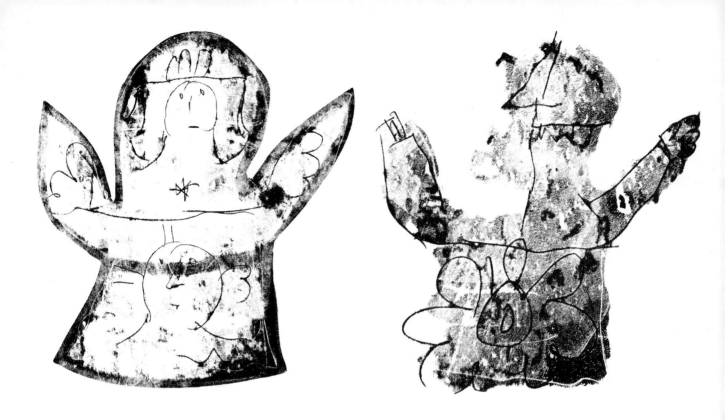

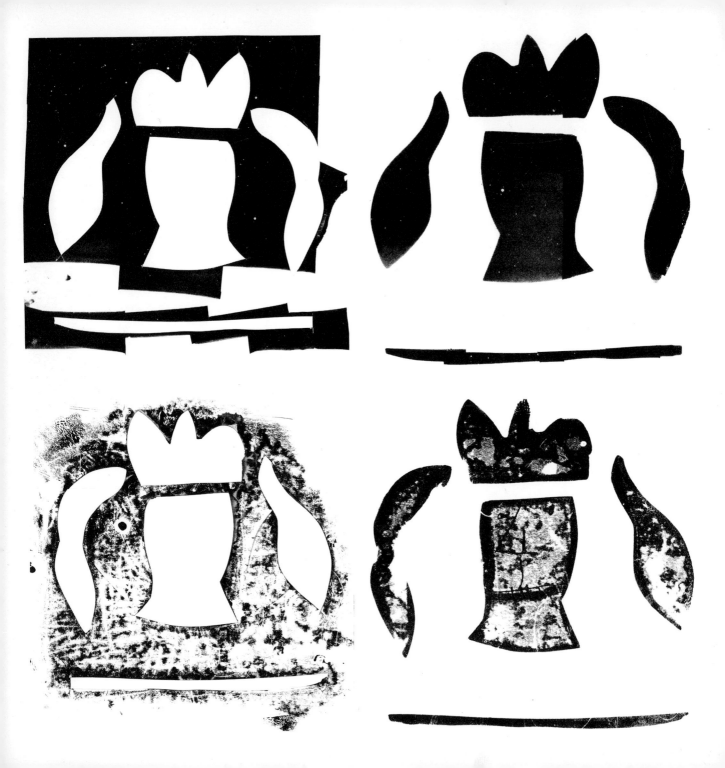

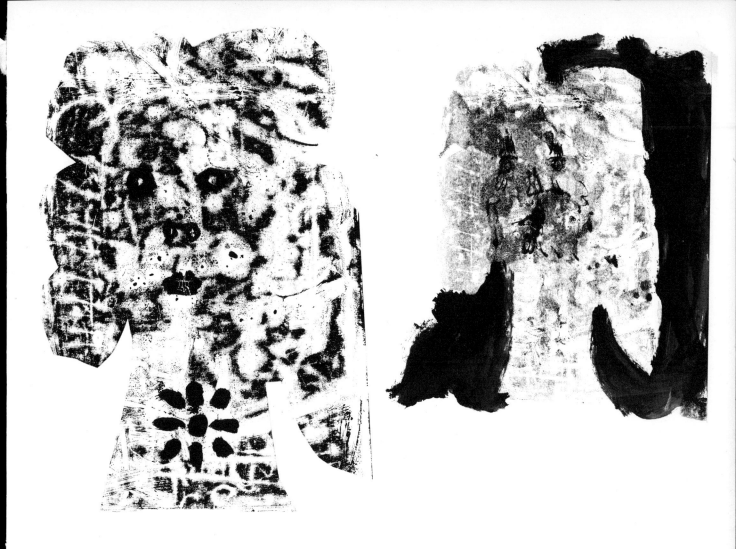

Left. Head of a Girl. The same as the
monoprint on the right, except in
this instance the paper has been cut
with a razor blade to eliminate the
unwanted background.

Right. Head of a Girl. A quick
drawing was made with minimal
lines to depict features of the head.
A heavy wash background drawing
delineates the shape of the girl's face.

Opposite Page

Four different applications of
stencil monoprint techniques.

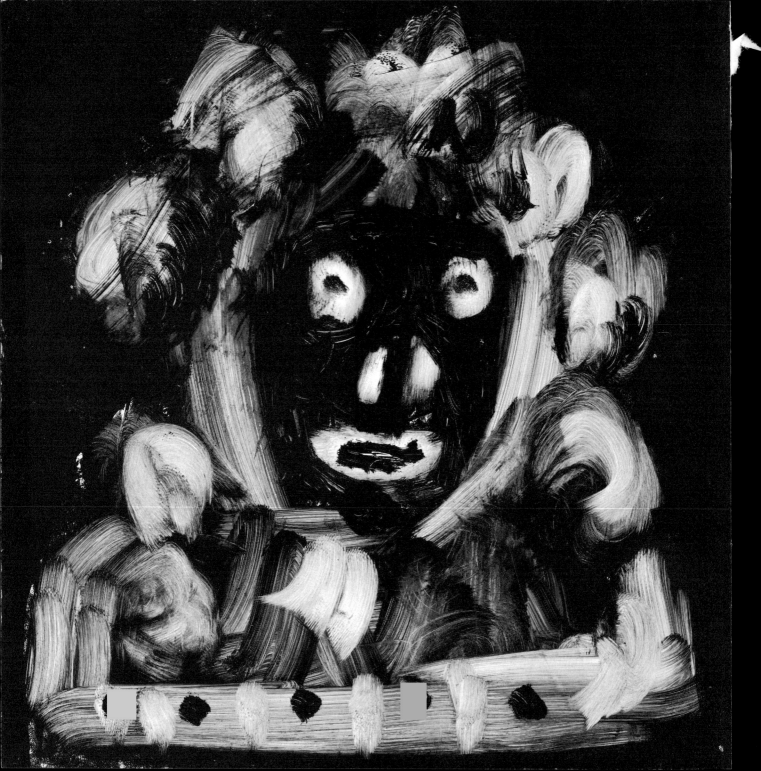

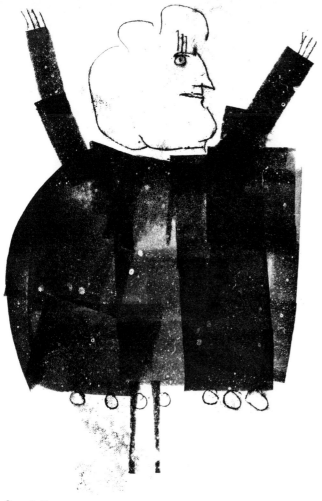

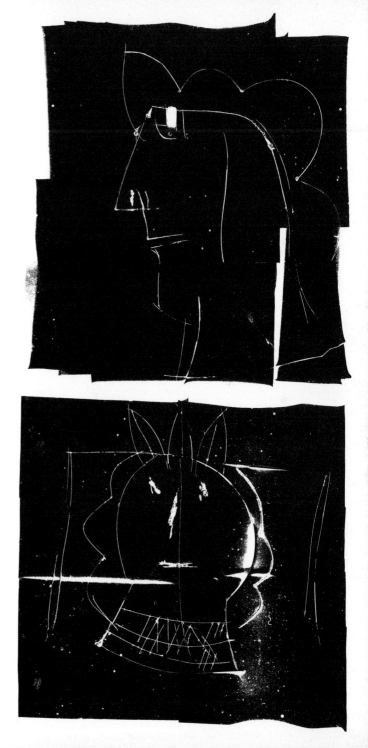

Opposite Page

Little Orphan Annie. A rag was used to take away the ink from (or draw into the ink on) the glass plate. The monoprint was printed with a piece of clear acetate instead of paper. Ink adheres extremely well to the acetate and then can be rubbed away to create many soft effects. The acetate can take extremely fine but visible scratched lines, can be colored by placing color magazine pages behind the monoprint drawing to achieve a stained glass effect or can be used as a negative in an enlarger for many photographic processes.

Above. Playing Card. The head, hands and feet were drawn on the back of the paper. A small roller filled in the ink which represents the body of the figure.

Above and below, right. Two Black Heads. The drawings of the heads were cut into the paper with a razor blade (using it in almost pencil-like fashion) before the paper was placed against the inked plate. The white lines on the surface convey a scarred impression.

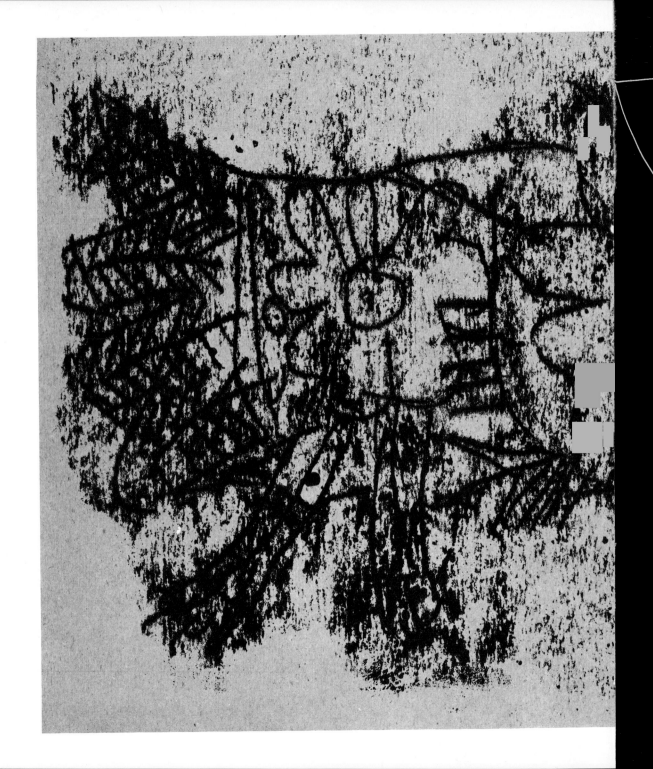

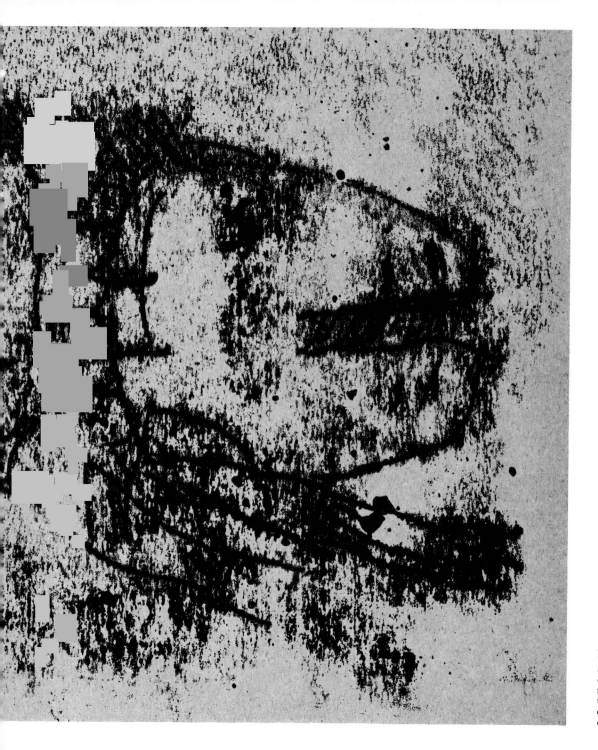

A Walking Fish. Pencil was used on a very heavy and porous brown cardboard to create this monoprint. Note how the texture of the cardboard contributes to the composition.

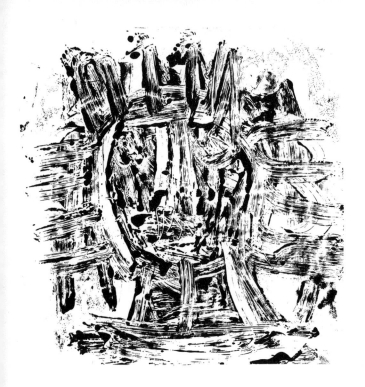

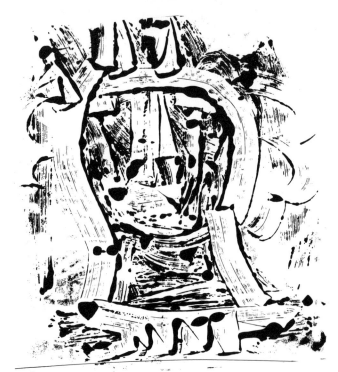

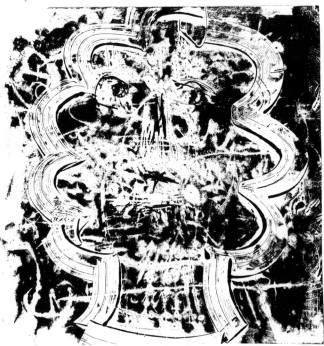

A series of monoprints produced by drawing directly onto the inked plate. The lines for the faces were produced by scraping away the ink with the side of a razor blade, or by removing it with a rag, a paint brush, and a tooth brush.

Opposite Page

Four Heads. Monoprints created by taking away ink or drawing directly on the inked plate with a toothbrush, rags, nails, a razor blade, pencil erasers, a steel stylus and a brush handle.

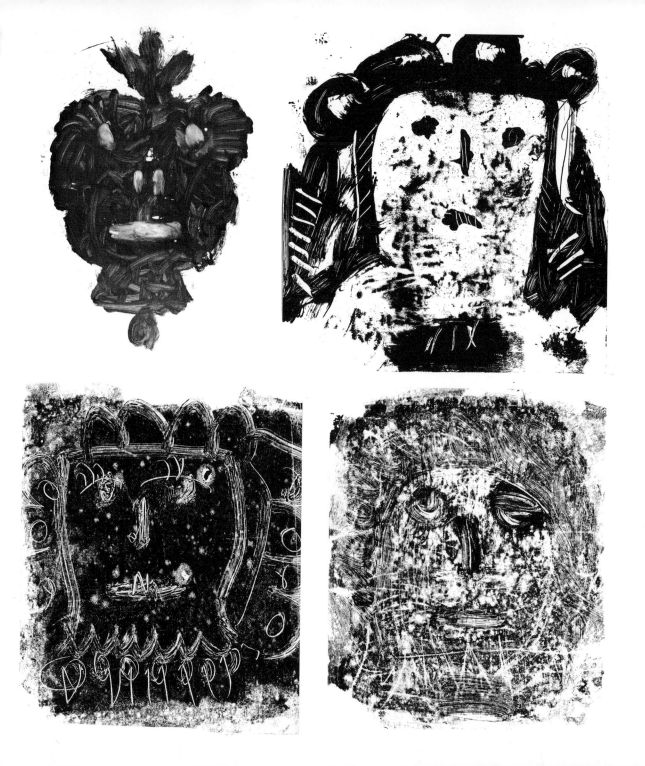

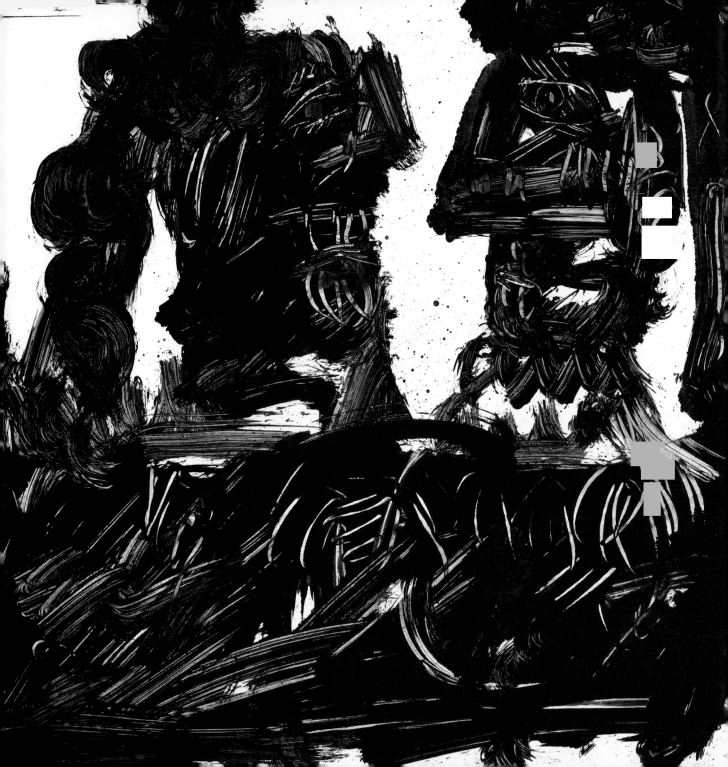

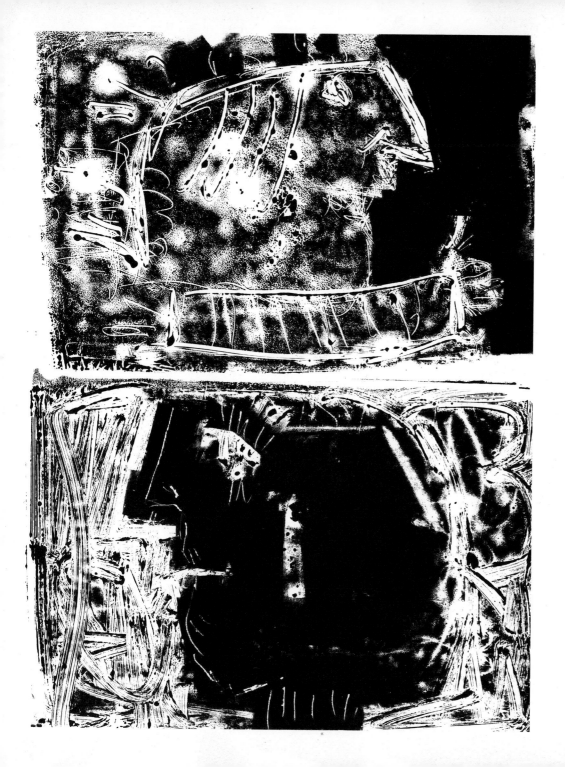

Opposite Page

The King and Queen in Profile.

Double Heads. The techniques used in these monoprints are similar to those described on page 94. In these examples additional lines and details were scratched into the monoprints when dry with a razor blade and nail.

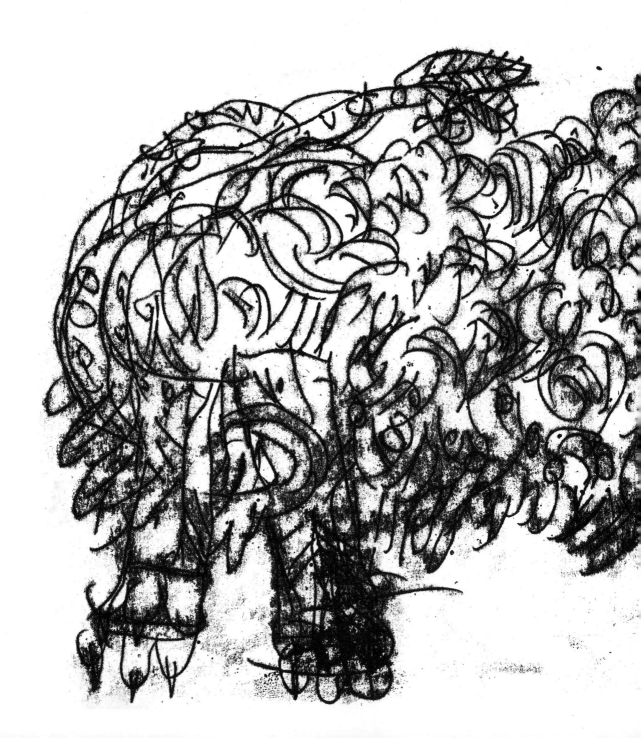

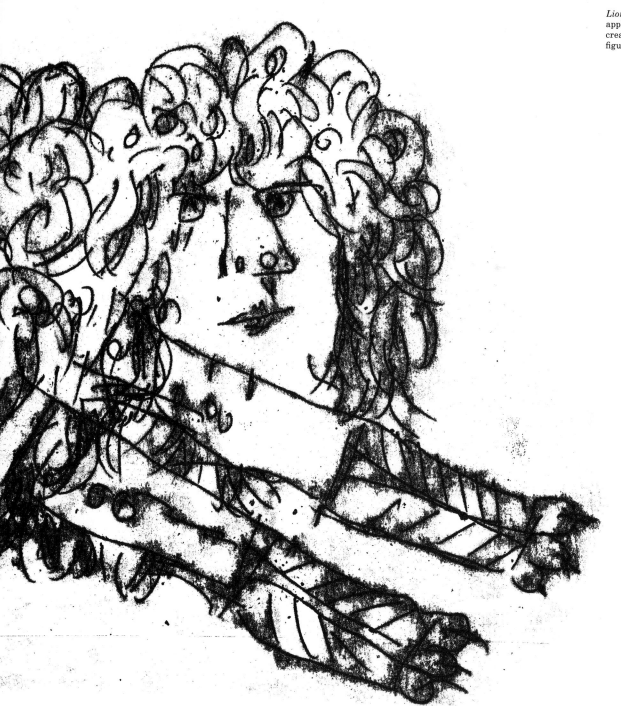

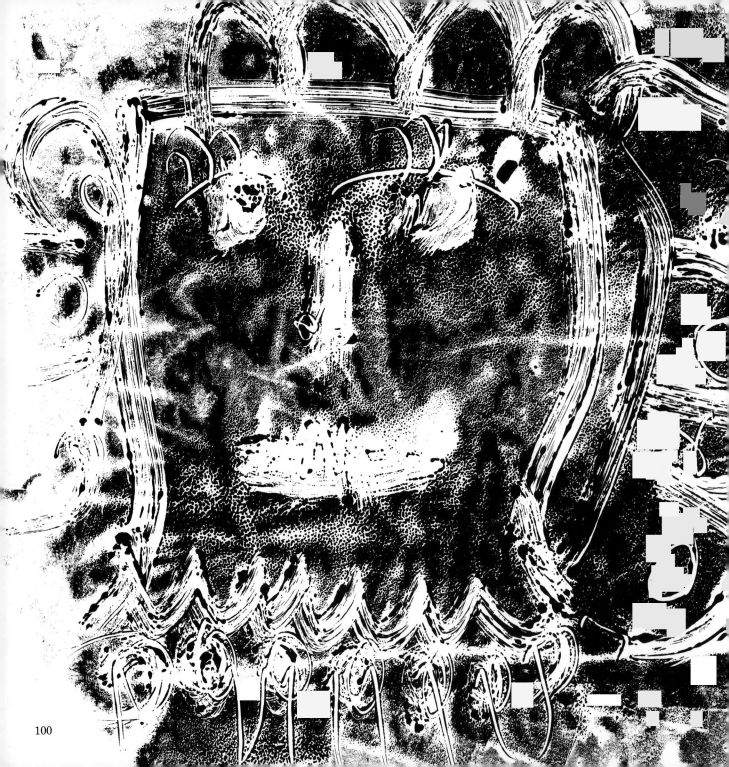

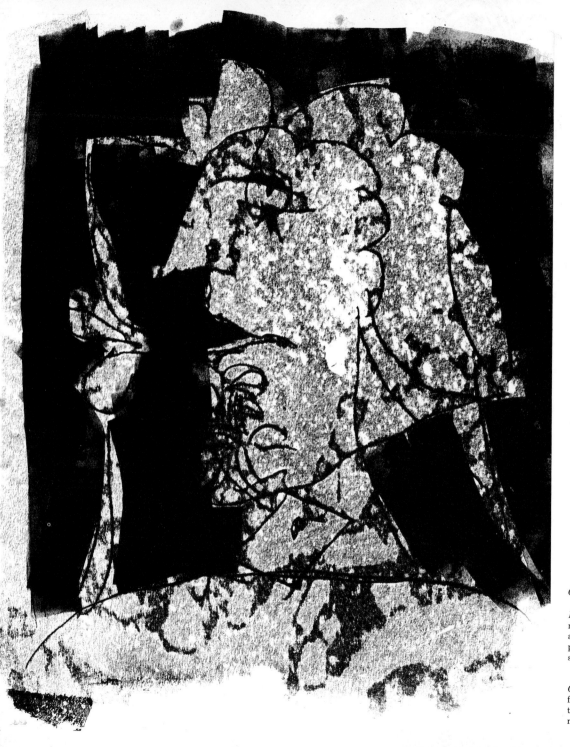

Opposite Page

Face. The ink in this
monoprint was rubbed
away directly from the
plate with a rag and the
side of a razor blade.

Gourmet. See page 76
for description of the
technique used in this
monoprint.

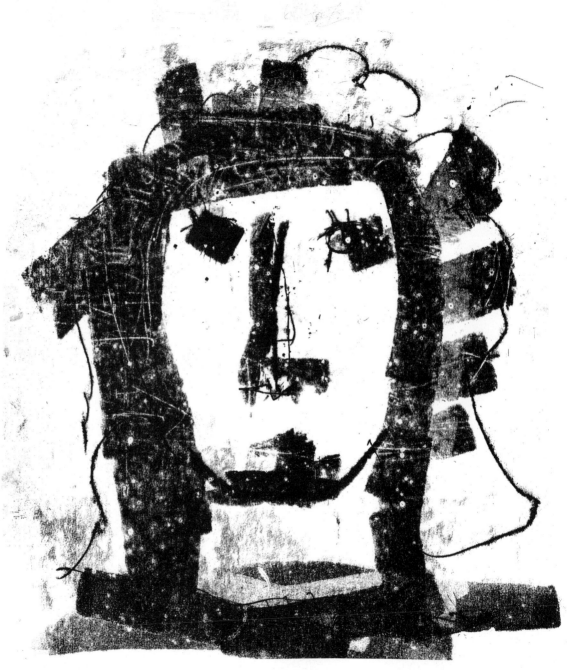

Mary Had A Little Lamb.
This monoprint combines
a number of techniques
including the use of a
small roller, finger
rubbing for light textures,
and additional pencil
scratchings after the
paper was pulled from
the plate.

Opposite Page

Cleopatra. See page 76 for
techniques used in this
monoprint.

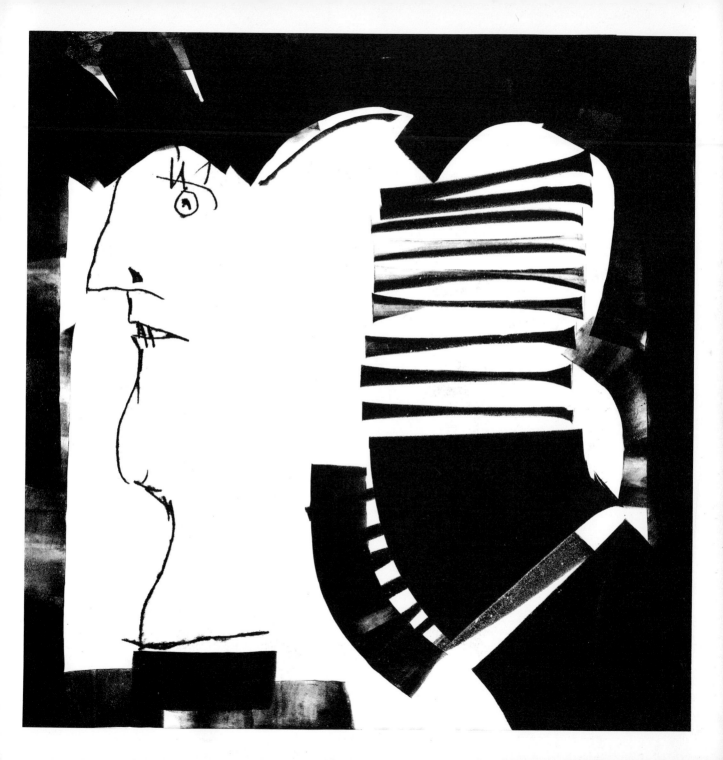

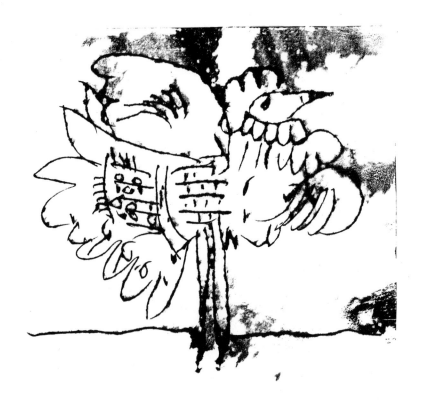